MEAT AMERICA

DOMINIC EPISCOPO

PHOTOGRAPHY © 2012 DOMINIC EPISCOPO

CREATIVE DIRECTION BY JORDAN GOLDENBERG
DESIGN BY SCOTT RICHARDS

MEATAMERICA.COM FACEBOOK.COM/MEATAMERICA

platypus
press

ISBN 978-0-9884668-0-7

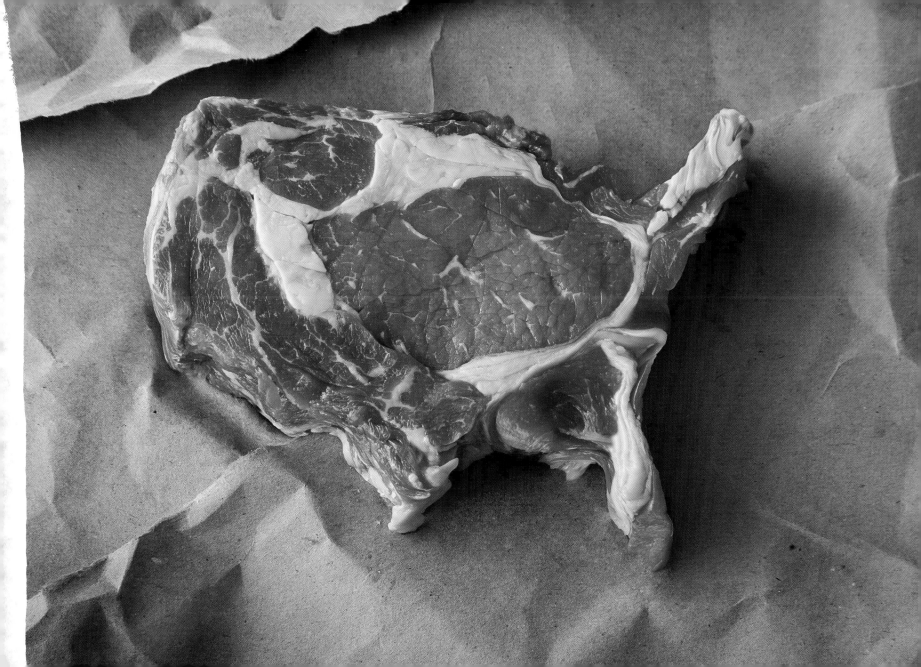

Meat America is an eye-opening and artery-closing tour of America's spirit of entrepreneurship, rebellion and positivity. It celebrates our collective American appetite for insurmountable odds, limitless aspiration, and immeasurable success. Though, some may just see it as a bunch of American icons fashioned out of animal products, which is totally cool too.

FART PROUDLY.

BENJAMIN FRANKLIN

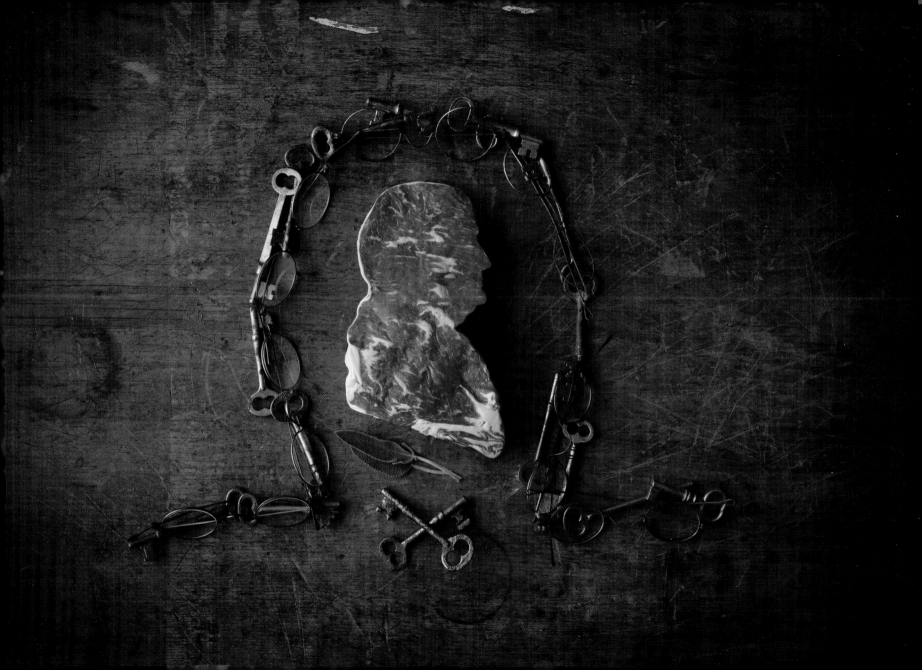

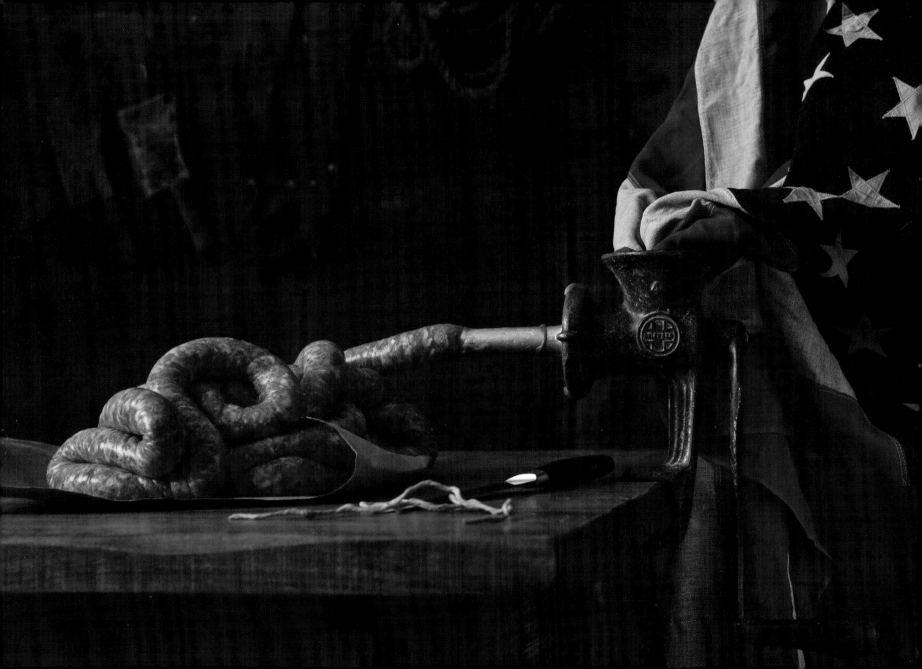

LAWS ARE LIKE SAUSAGES, IT IS BETTER
NOT TO SEE THEM BEING MADE.

OTTO VON BISMARCK

THE ONLY TRUE WISDOM IS IN KNOWING
YOU KNOW NOTHING.

SOCRATES

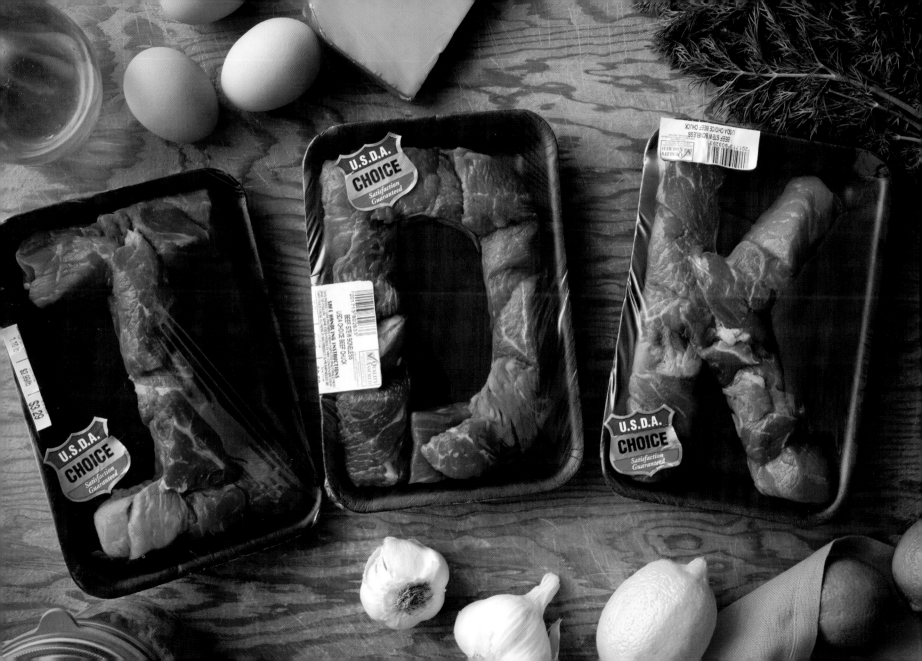

BEFORE BECOMING
OUR BEST BEARDED PRESIDENT,
HONEST ABE WAS KNOWN FOR HIS
EPIC BUTCHERING SKILLS.

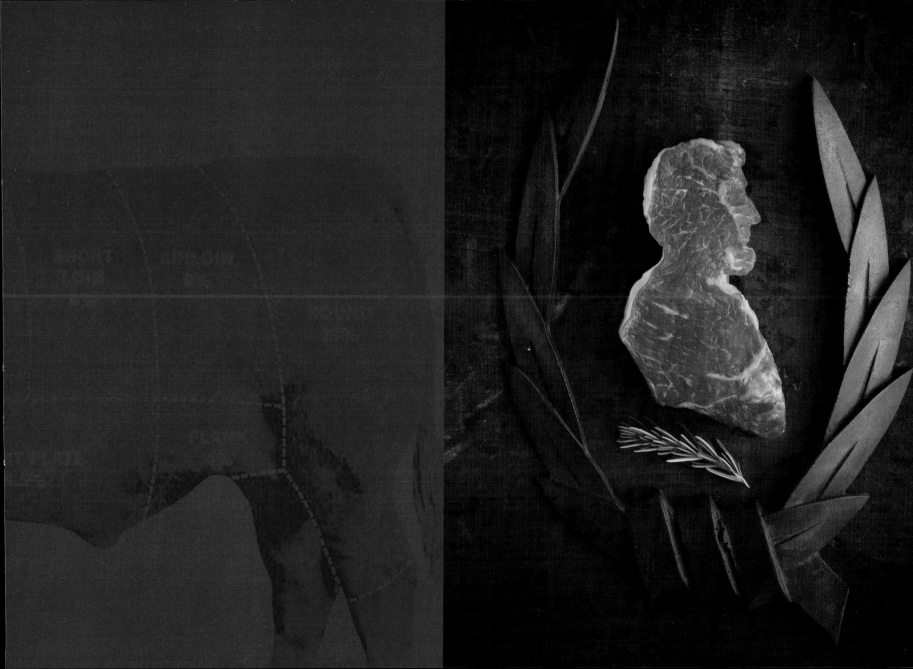

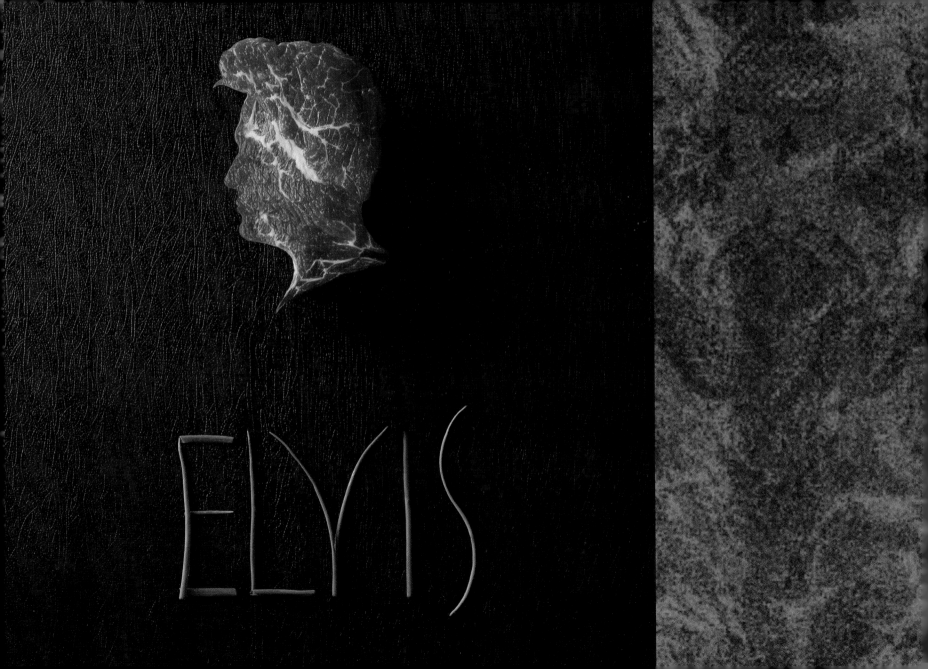

LOVE ME TENDER.

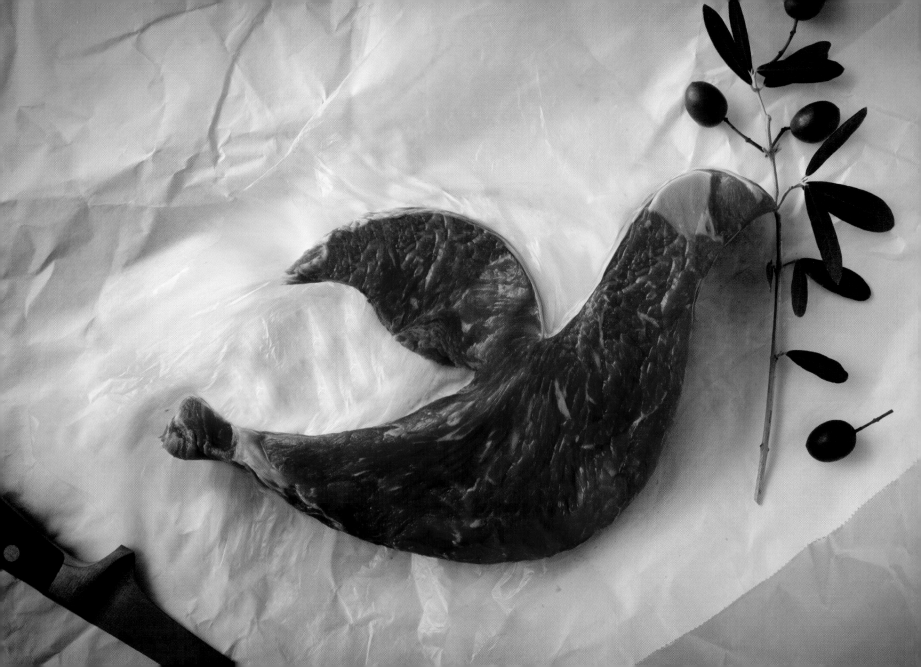

I AM BECAUSE WE ARE.
WE ALL BLEED THE SAME
COLOR. WE ALL WANT TO
LOVE AND BE LOVED.

MADONNA

DEATH IS THE DESTINATION WE ALL SHARE. NO ONE HAS EVER ESCAPED IT. AND THAT IS AS IT SHOULD BE, BECAUSE DEATH IS VERY LIKELY THE SINGLE BEST INVENTION OF LIFE.

STEVE JOBS

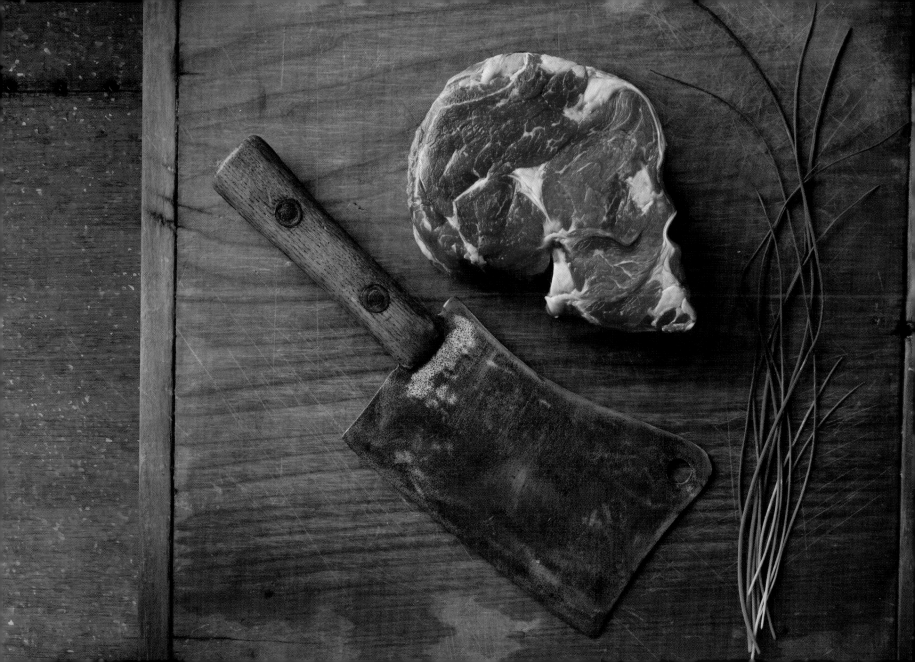

ONE SMALL BEEF PATTY

CAN HAVE ANYWHERE FROM FIFTY TO OVER A THOUSAND DIFFERENT
CATTLE FROM FIVE DIFFERENT COUNTRIES.

WHEN YOU SEE A RATTLESNAKE POISED TO STRIKE, YOU DO NOT WAIT UNTIL HE HAS STRUCK TO CRUSH HIM.

FRANKLIN D. ROOSEVELT

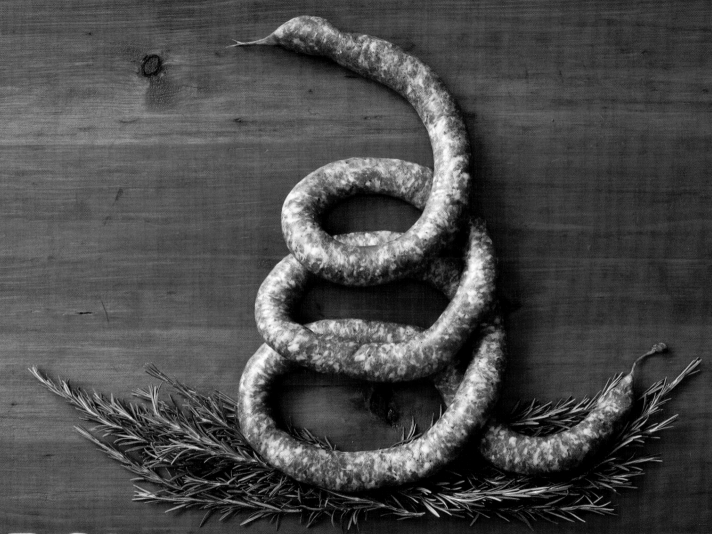

DONT TREAD ON MEAT

ONE DAY WE'LL LOOK BACK ON THIS, AND IT WILL ALL SEEM FUNNY.

BRUCE SPRINGSTEEN

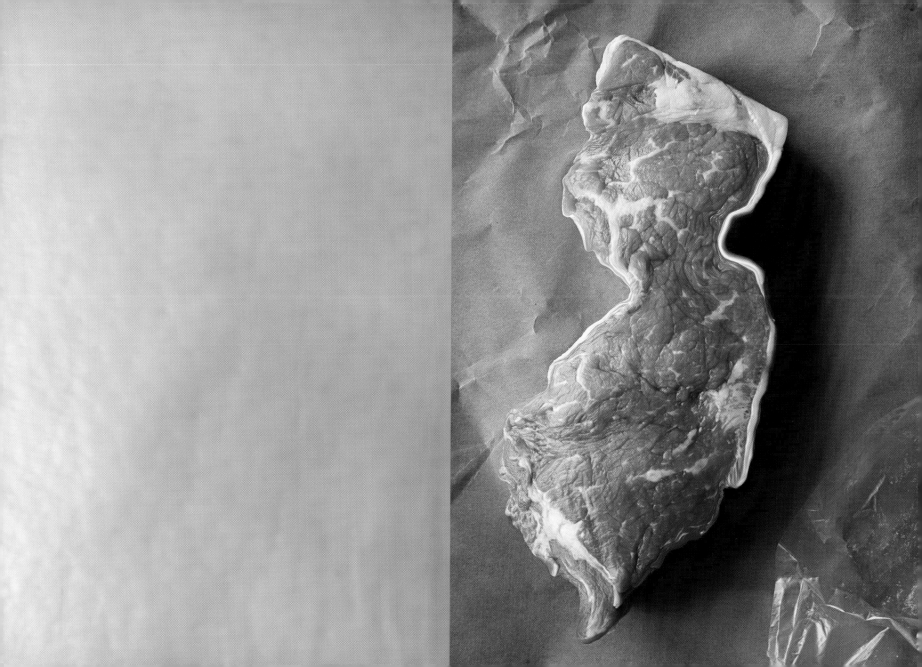

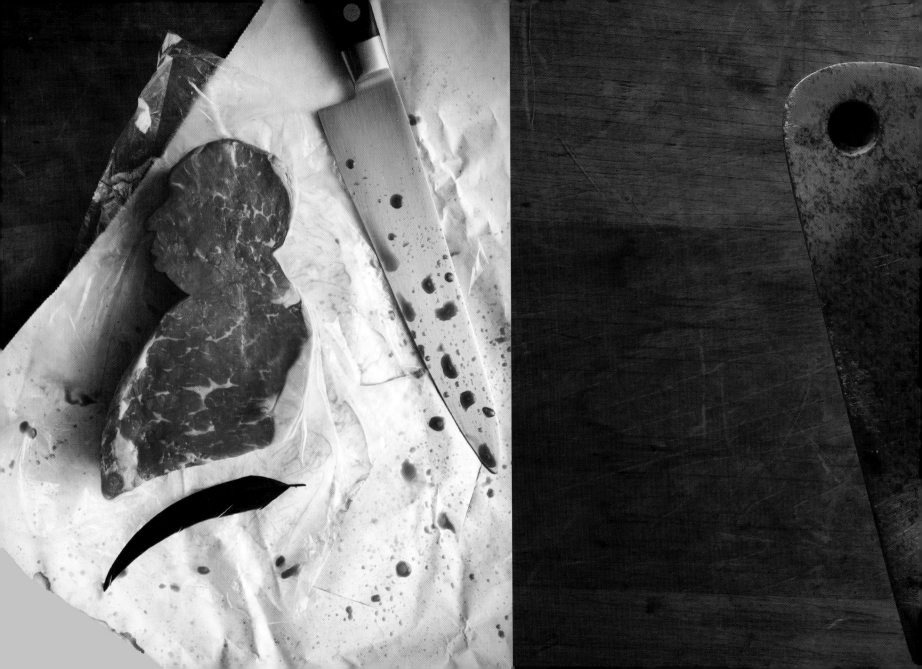

REVENGE IS SWE
AND NOT FATTEN

ALFRED HITCHCOCK

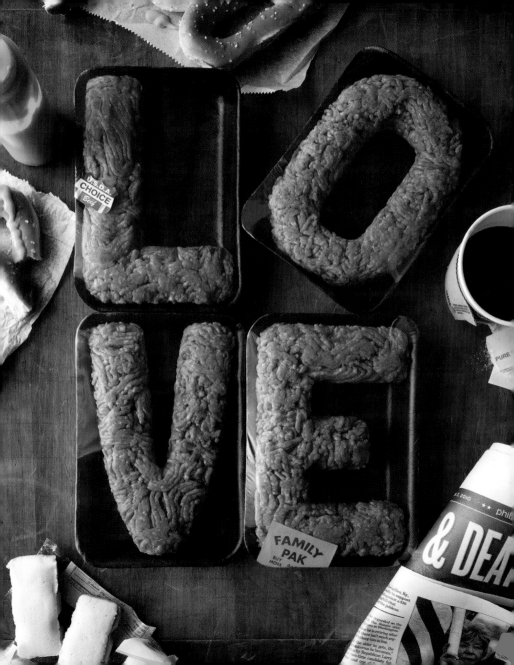

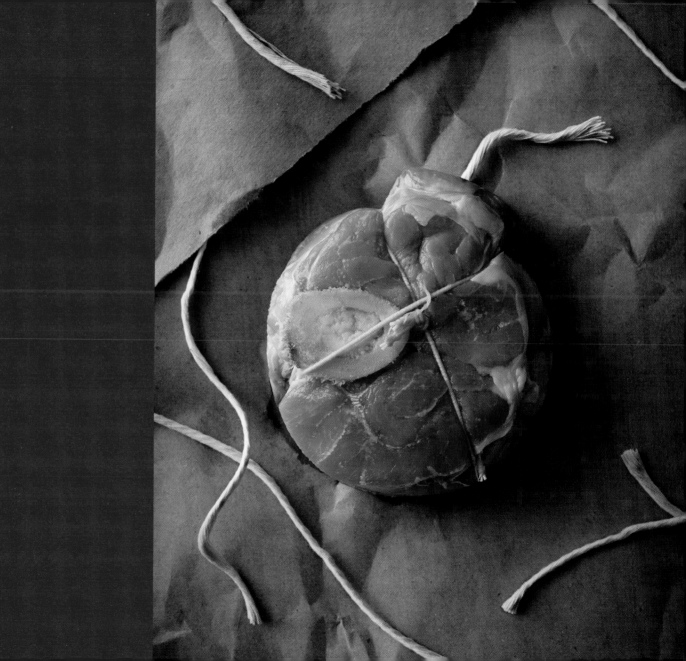

NOT

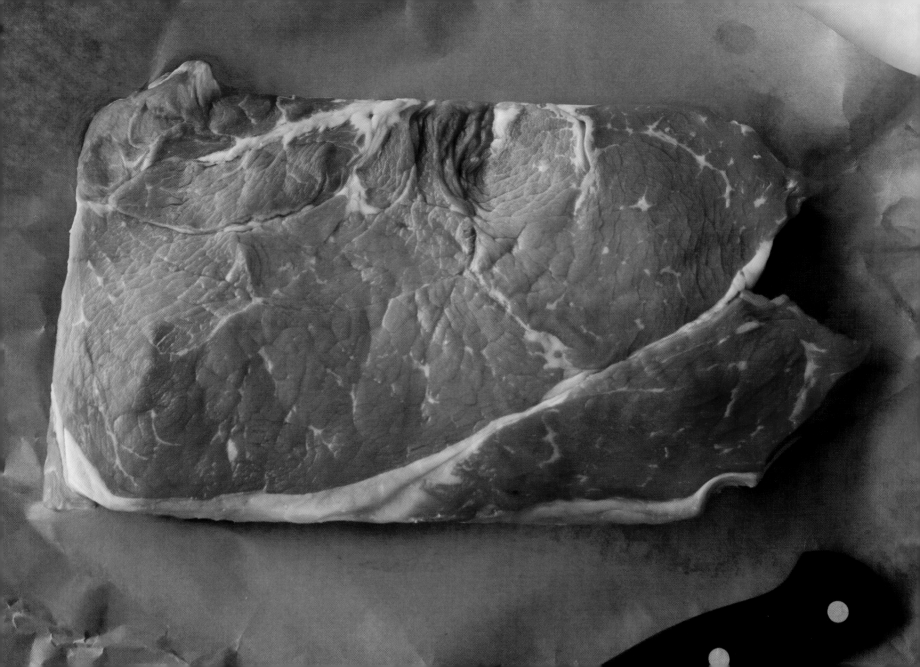

PENNSYLVANIA LEADS THE NATION

IN THE NUMBER OF LICENSED HUNTERS, STATE GAME LANDS,
MEAT PACKING PLANTS, AND SAUSAGE PRODUCTION.

YOU KNOW WHY THERE'S A SECOND AMENDMENT? IN CASE THE GOVERNMENT FAILS TO FOLLOW THE FIRST ONE.

RUSH LIMBAUGH

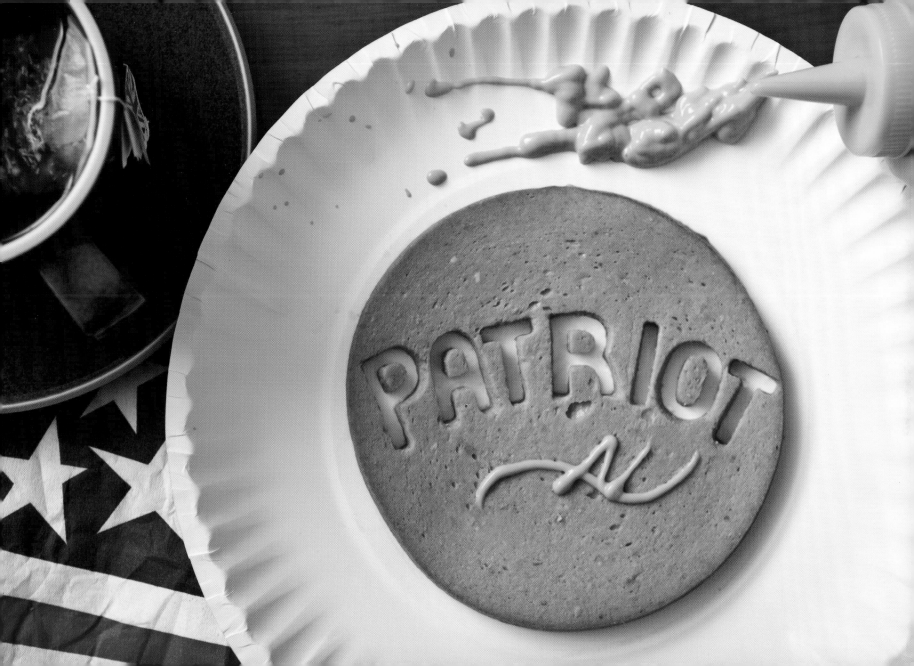

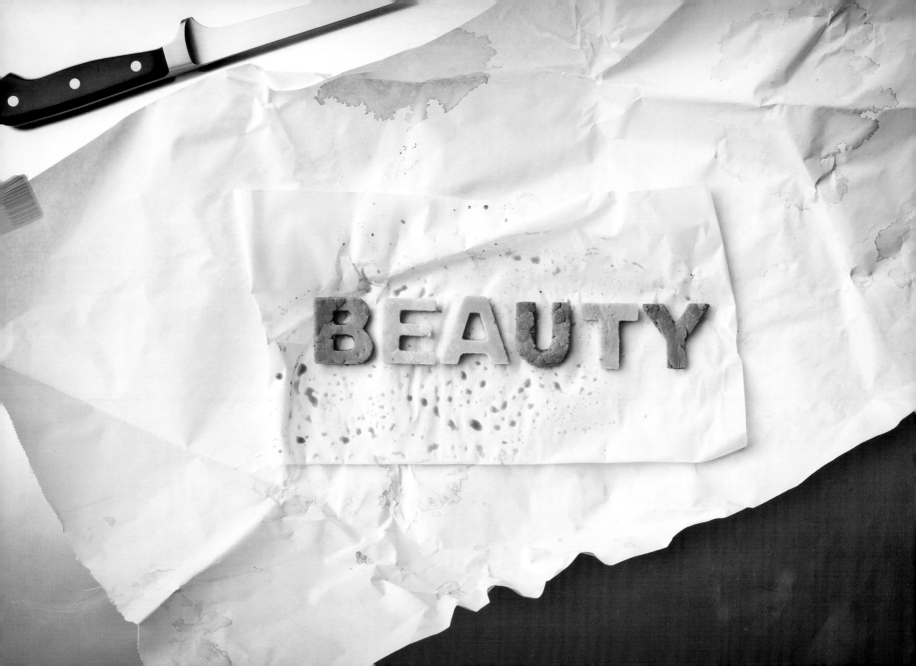

I LOVE LA. I LOVE HOLLYWOOD. THEY'RE BEAUTIFUL. EVERYBODY'S PLASTIC, BUT I LOVE PLASTIC. I WANT TO BE PLASTIC.

ANDY WARHOL

COMMUNISM DOESN'T WORK,
BECAUSE PEOPLE LIKE
TO OWN STUFF.

FRANK ZAPPA

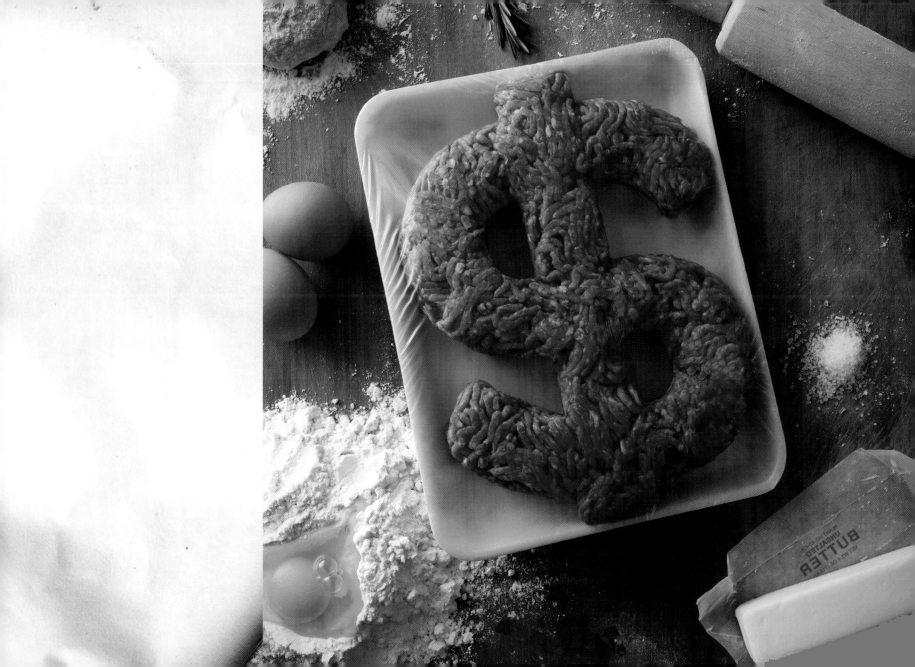

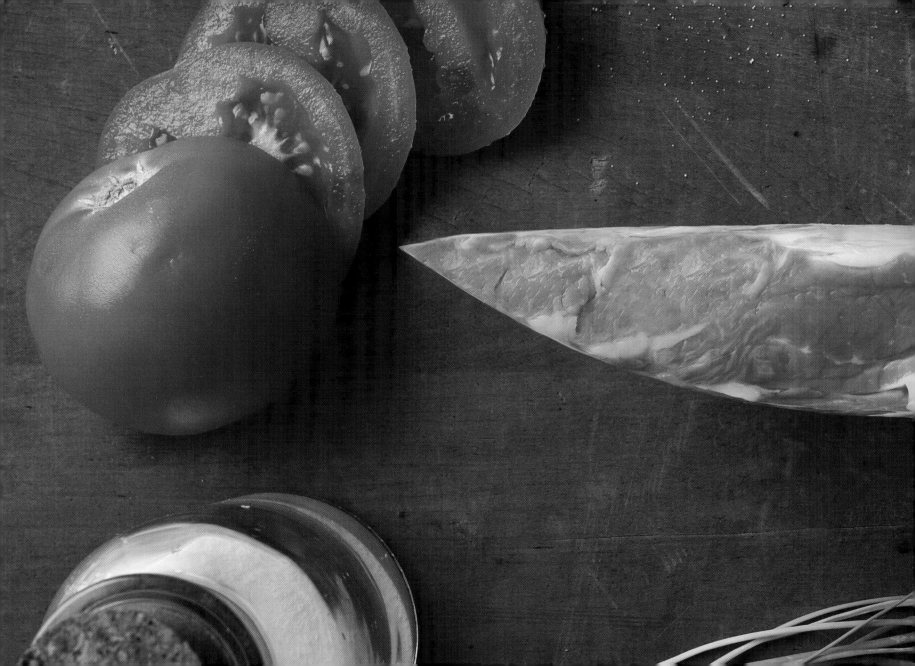

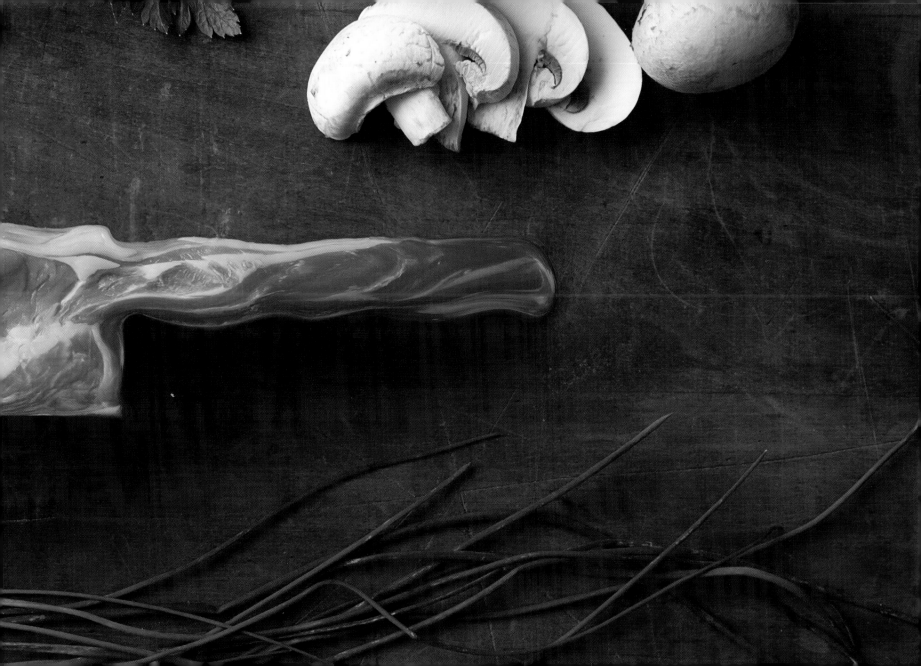

WE MUST ALL HANG TOGETHER, OR, ASSUREDLY, WE SHALL ALL HANG SEPARATELY.

BENJAMIN FRANKLIN

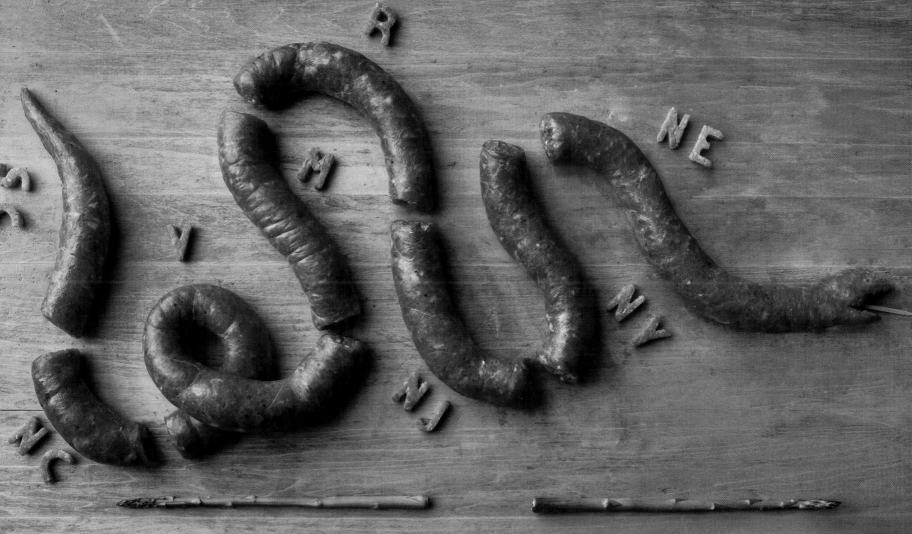

UNITE, OR DIET.

SOME FOLKS LOOK AT ME AND SEE A CERTAIN SWAGGER, WHICH IN TEXAS IS CALLED "WALKING".

GEORGE W. BUSH

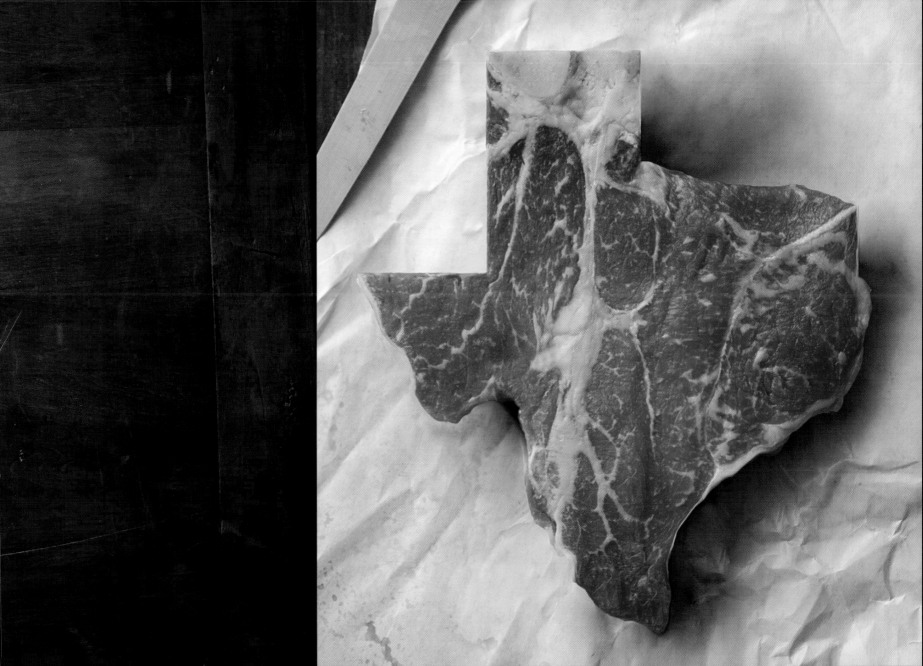

ANY IDIOT CAN GET LAID
WHEN THEY'RE FAMOUS. THAT'S EASY.
IT'S GETTING LAID WHEN YOU'RE NOT
FAMOUS THAT TAKES SOME TALENT.

KEVIN BACON

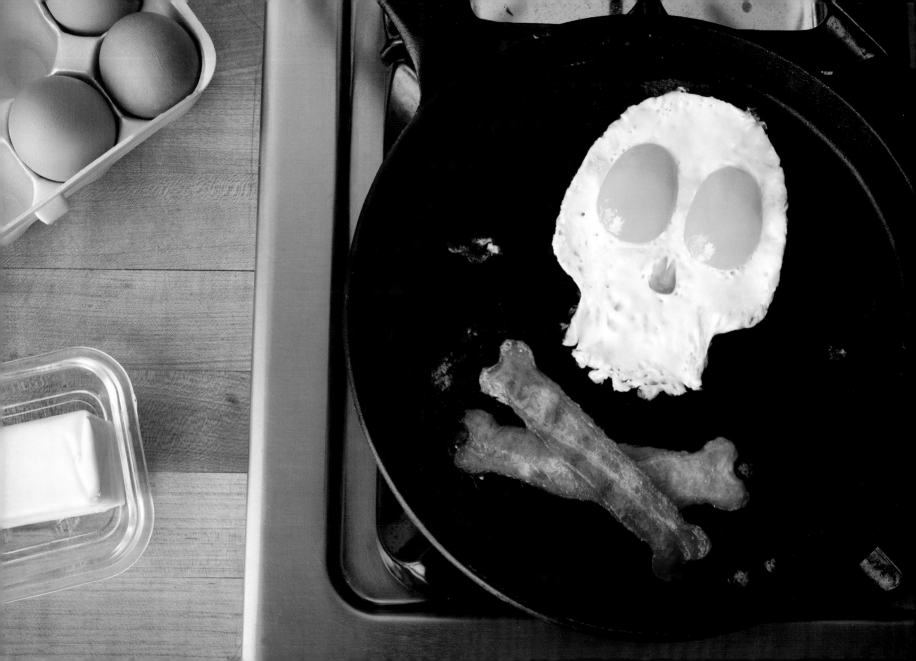

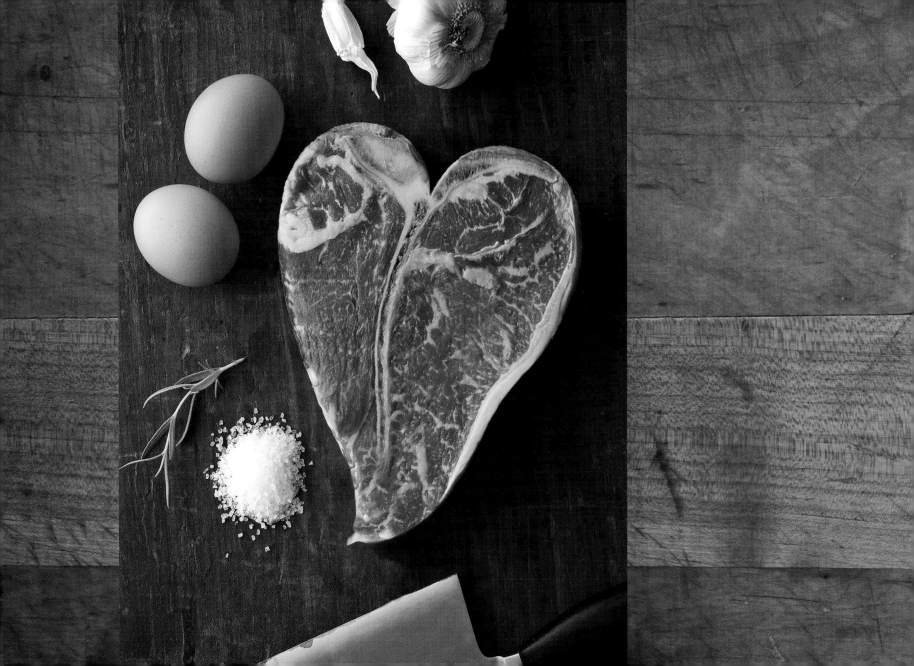

GIRLS BORED ME, THEY STILL DO.
I LOVE MICKEY MOUSE MORE THAN
ANY WOMAN I'VE EVER KNOWN.

WALT DISNEY

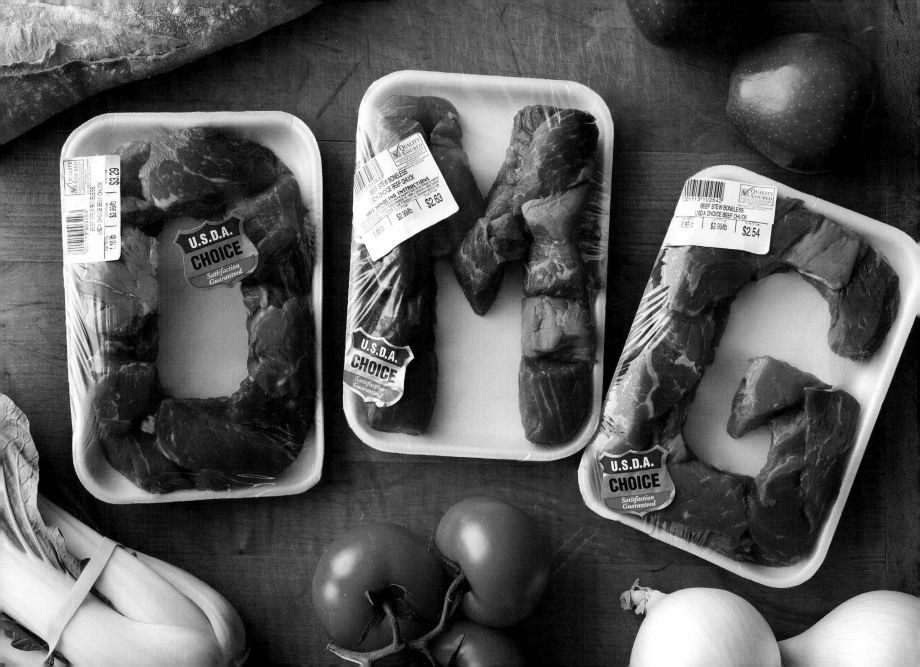

THEY CAN'T SCARE ME, IF I SCARE THEM FIRST.

LADY GAGA

MY PARENTS DIDN'T WANT TO MOVE TO FLORIDA, BUT THEY TURNED SIXTY AND THAT'S THE LAW.

JERRY SEINFELD

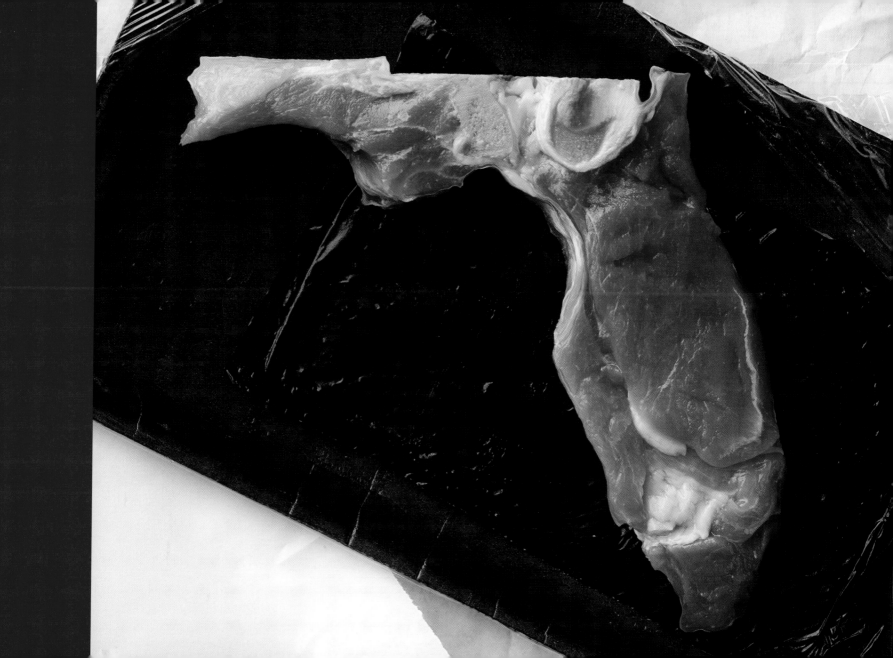

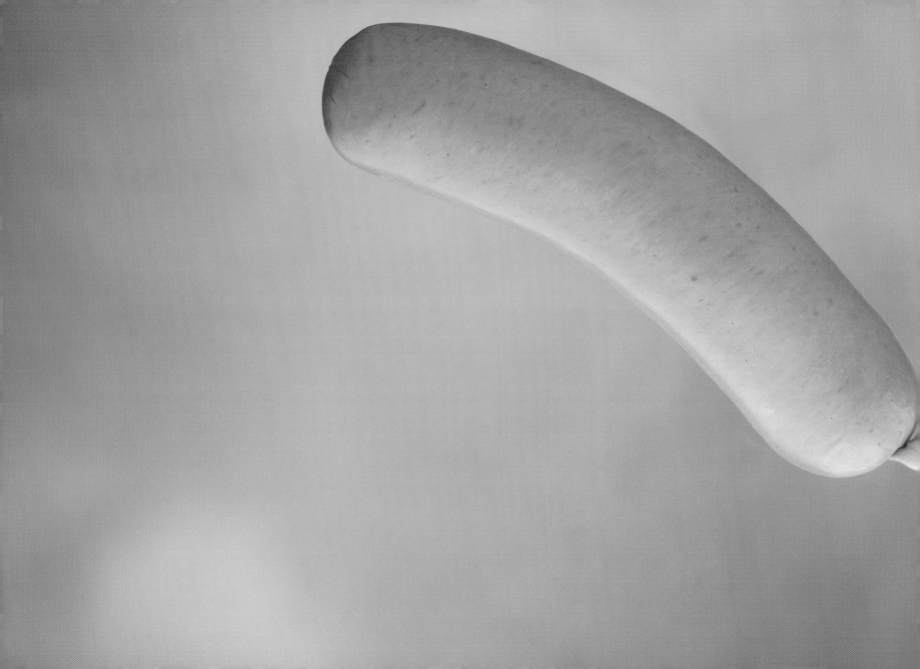

I NEVER THINK OF THE FUTURE -
IT COMES SOON ENOUGH.

ALBERT EINSTEIN

I HATE TO ADVOCATE DRUGS, ALCOHOL, VIOLENCE, OR INSANITY TO ANYONE, BUT THEY'VE ALWAYS WORKED FOR ME.

HUNTER S. THOMPSON

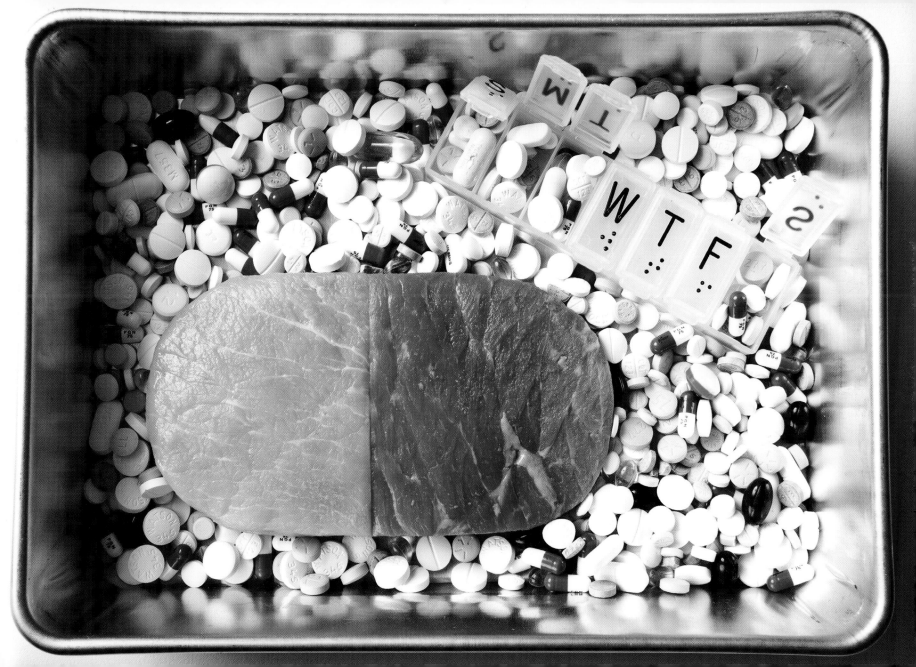

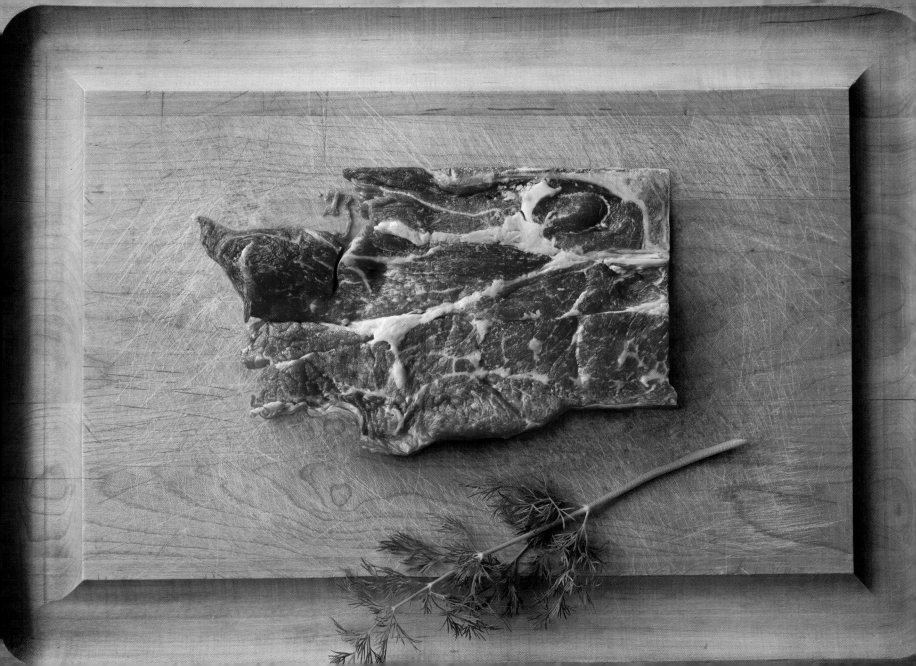

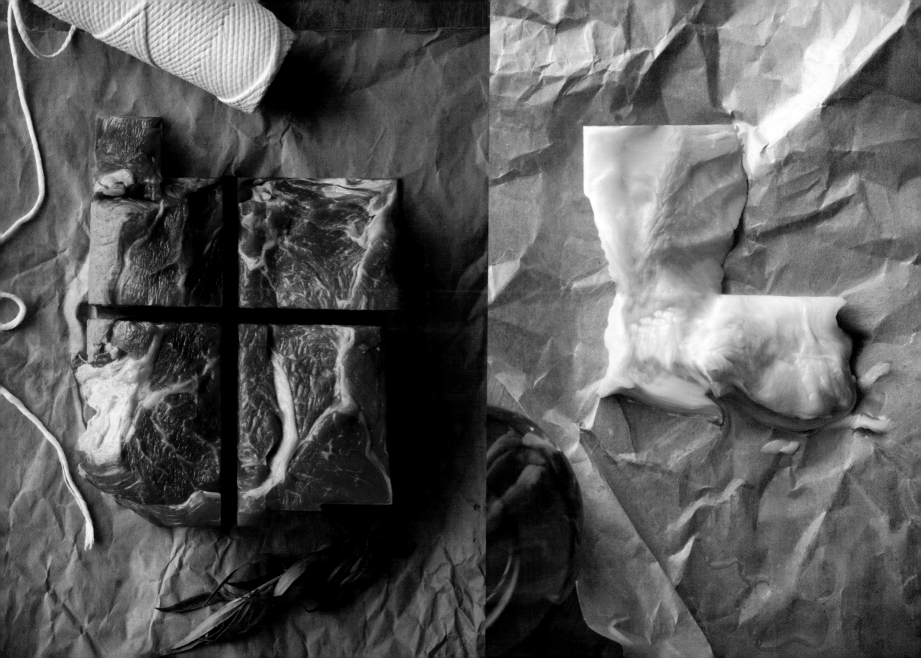

IF I HAD A BELL
I'D RING IT IN THE MORNING
I'D RING IT IN THE EVENING ... ALL OVER
THIS LAND,
I'D RING OUT DANGER
I'D RING OUT A WARNING
I'D RING OUT LOVE BETWEEN ALL OF MY
BROTHERS AND MY SISTERS
ALL OVER THIS LAND.
...
IT'S A BELL OF FREEDOM

LEE HAYS AND PETE SEEGER

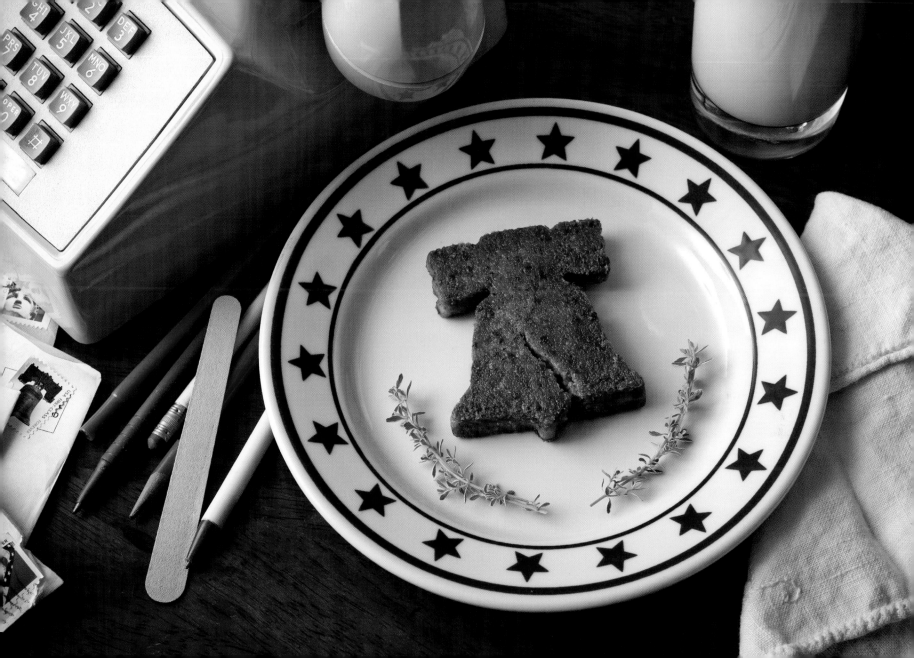

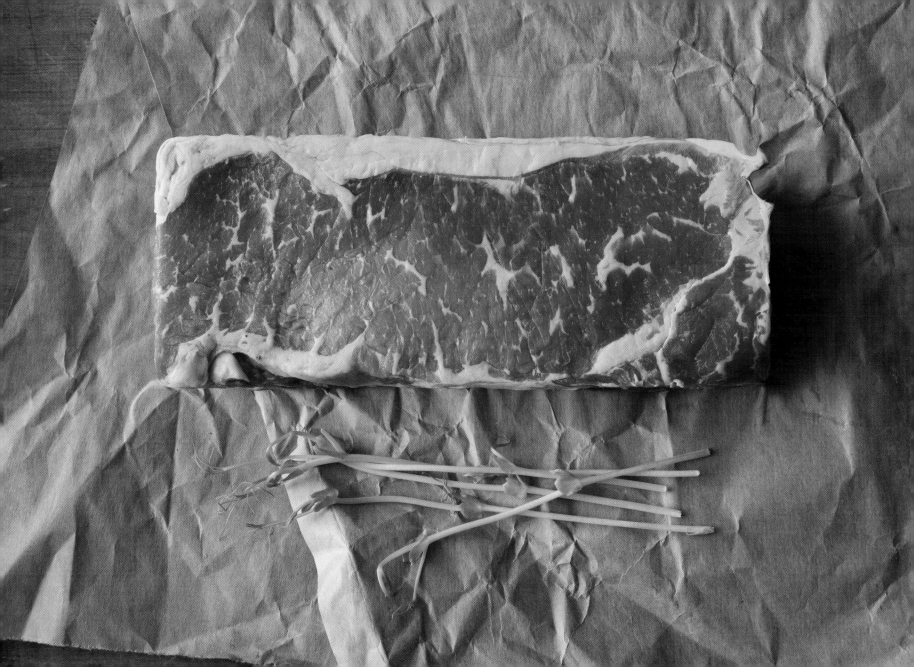

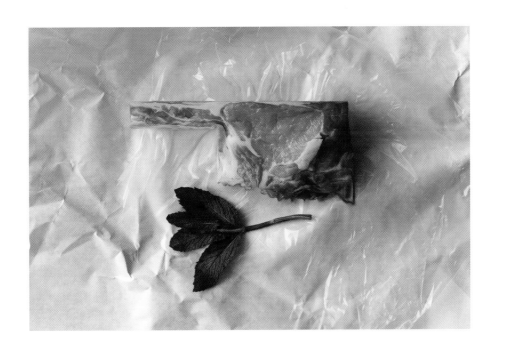

I'M JUST LIKE ANYONE. I CUT AND I BLEED.

MICHAEL JACKSON

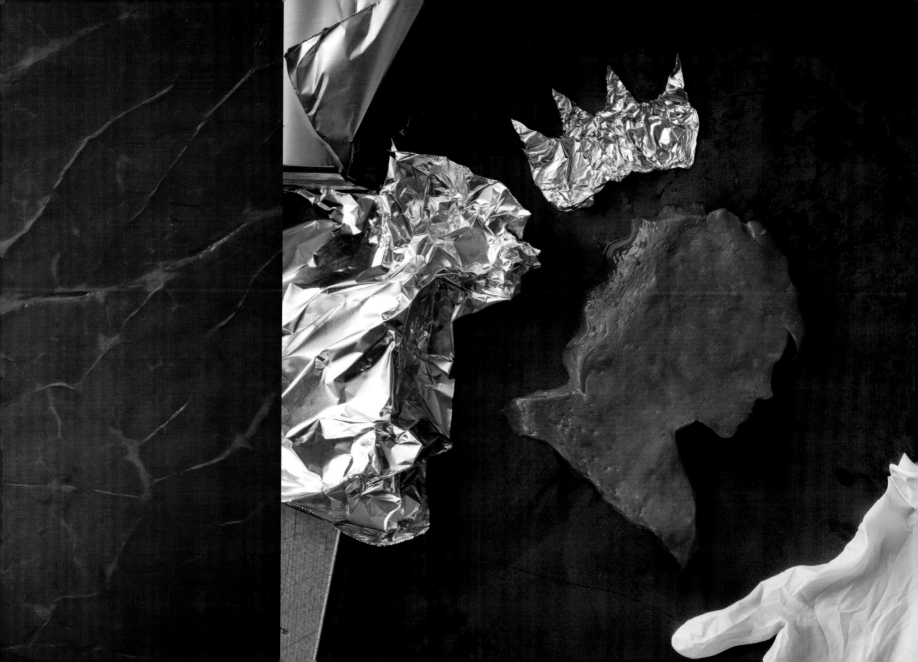

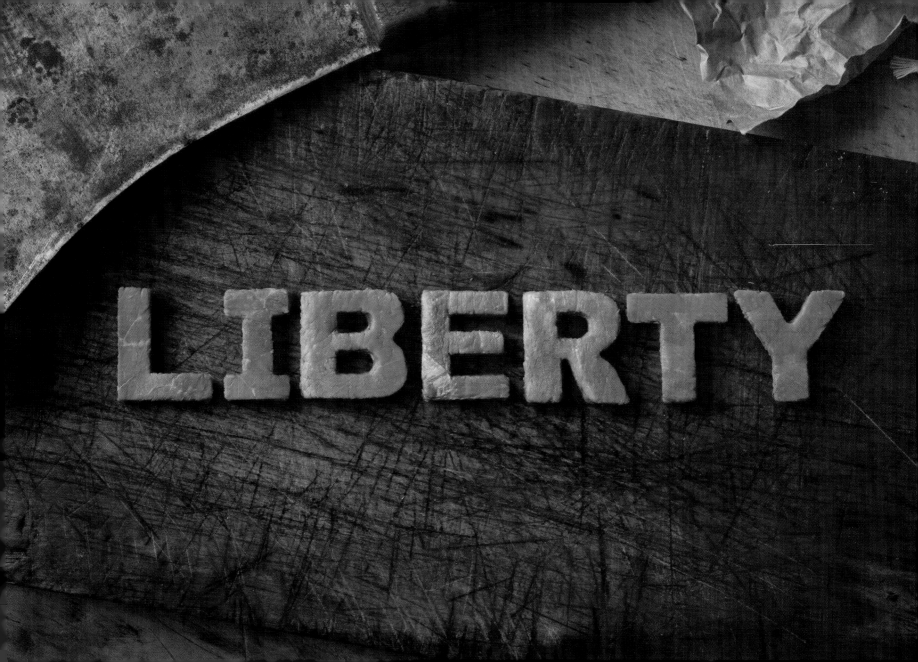

THE TREE OF LIBERTY MUST BE REFRESHED FROM TIME TO TIME WITH THE BLOOD OF PATRIOTS AND TYRANTS.

THOMAS JEFFERSON

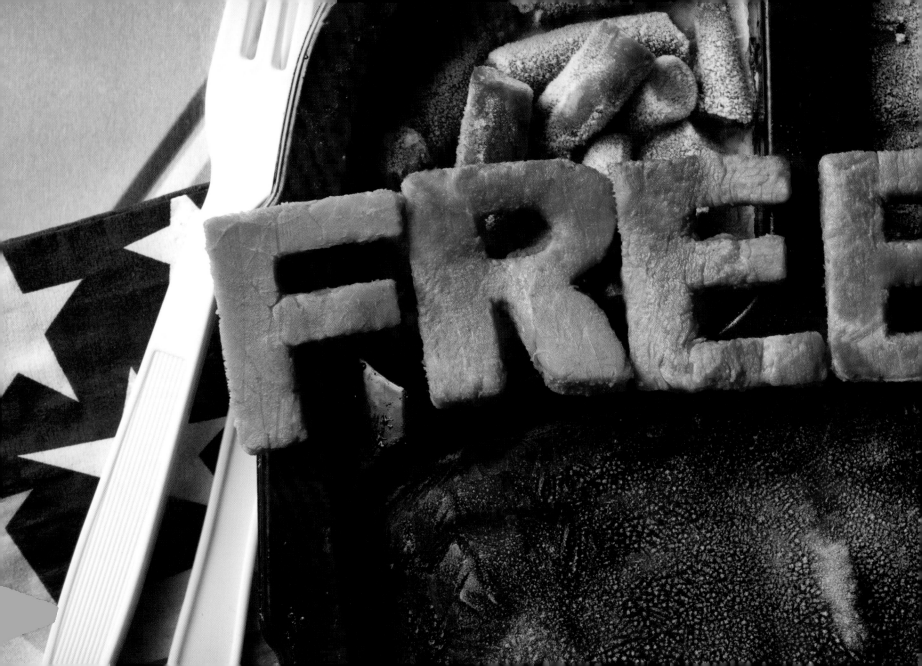

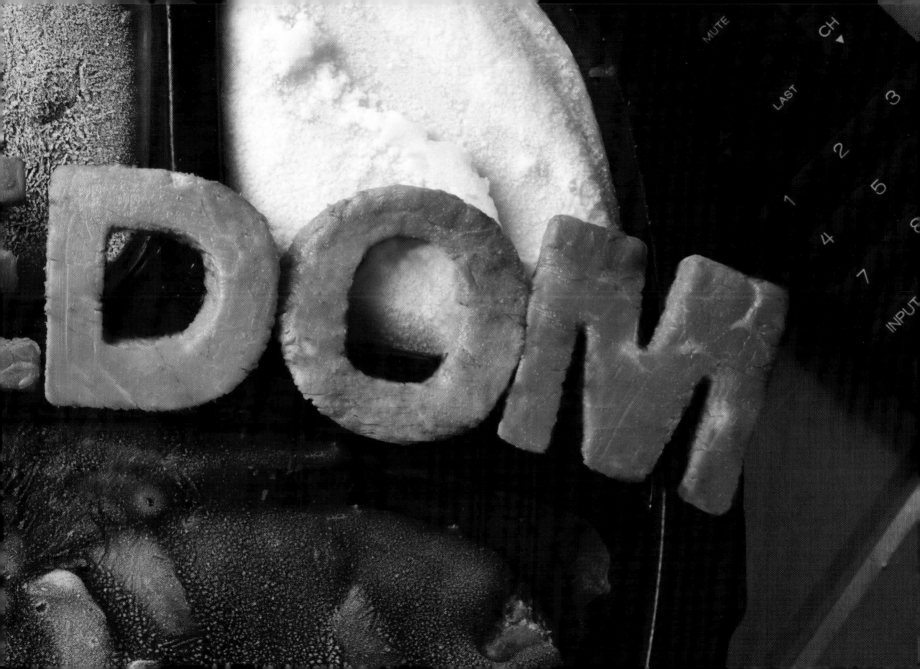

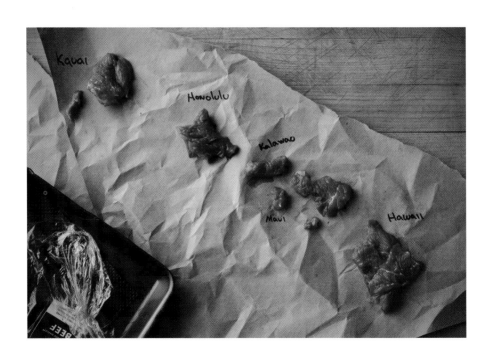

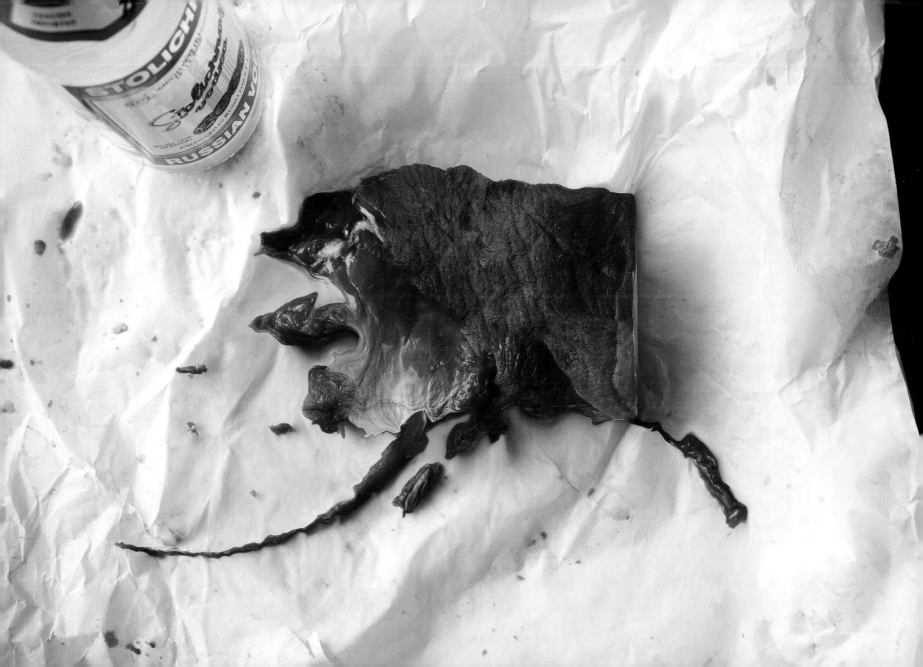

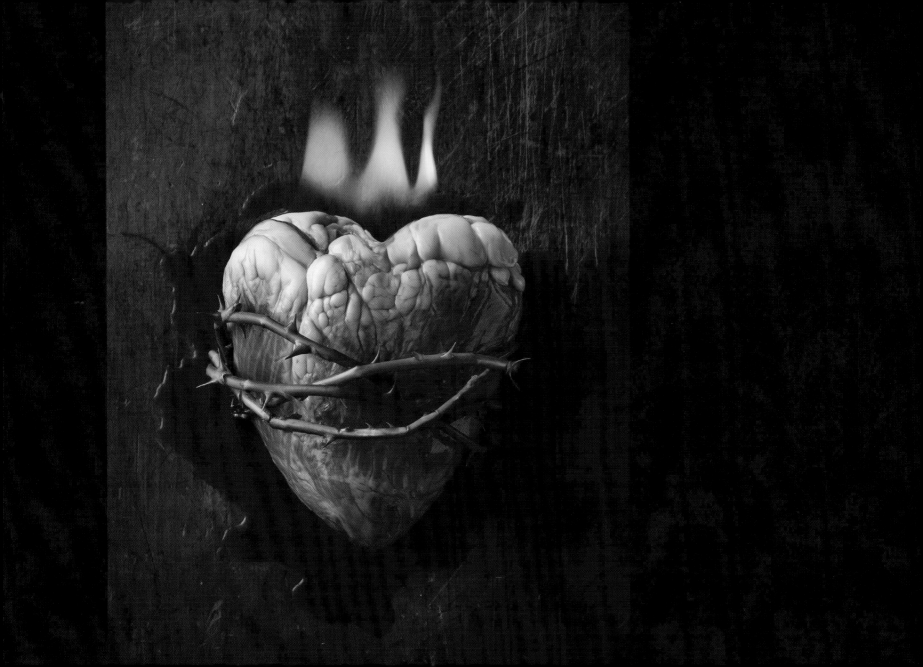

THE TIME I BURNED MY GUITAR IT WAS LIKE A SACRIFICE. YOU SACRIFICE THE THINGS YOU LOVE.

JIMI HENDRIX

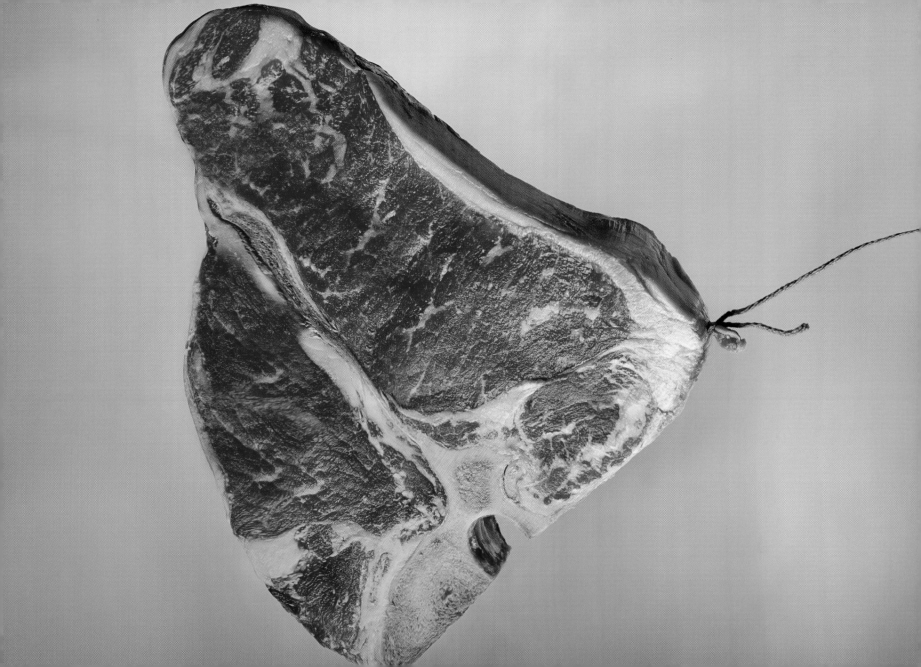

NO ONE SHOULD NEGOTIATE
THEIR DREAMS.
DREAMS MUST BE FREE TO FLY
HIGH. NO GOVERNMENT, NO
LEGISLATURE, HAS A RIGHT TO
LIMIT YOUR DREAMS.
YOU SHOULD NEVER AGREE
TO SURRENDER YOUR DREAMS.

JESSE JACKSON

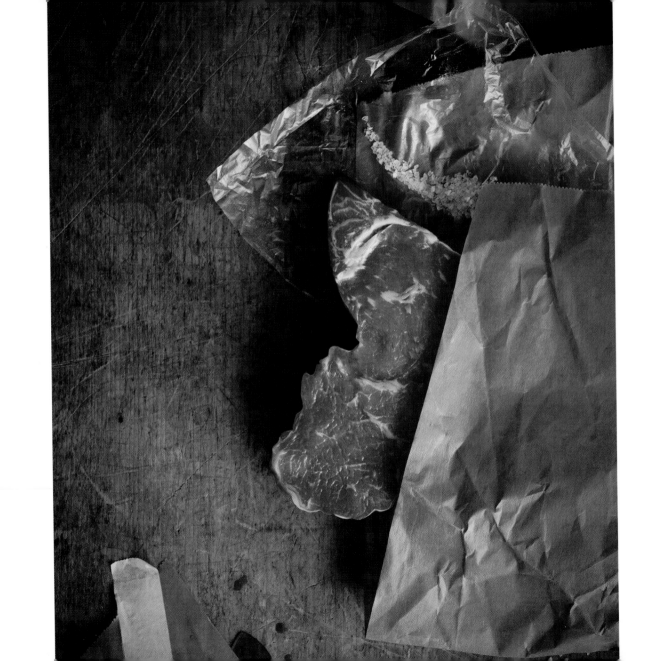

NO ONE IS FREE, EVEN THE BIRDS ARE CHAINED TO THE SKY.

BOB DYLAN

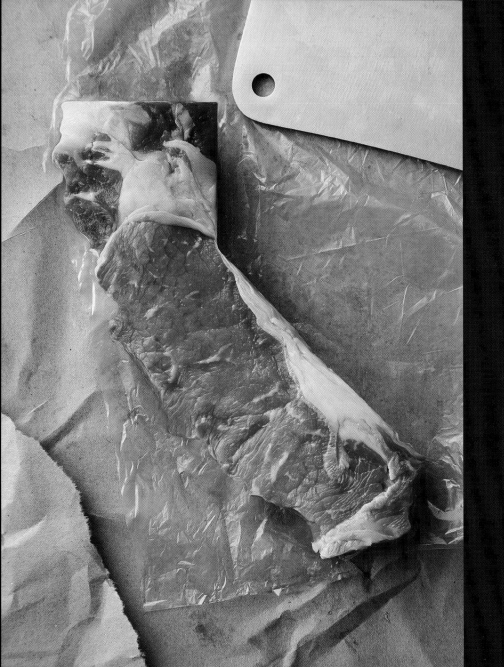

THANKS TO THE INTERSTATE HIGHWAY SYSTEM, IT IS NOW POSSIBLE TO TRAVEL ACROSS THE COUNTRY FROM COAST TO COAST WITHOUT SEEING ANYTHING.

CHARLES KURALT

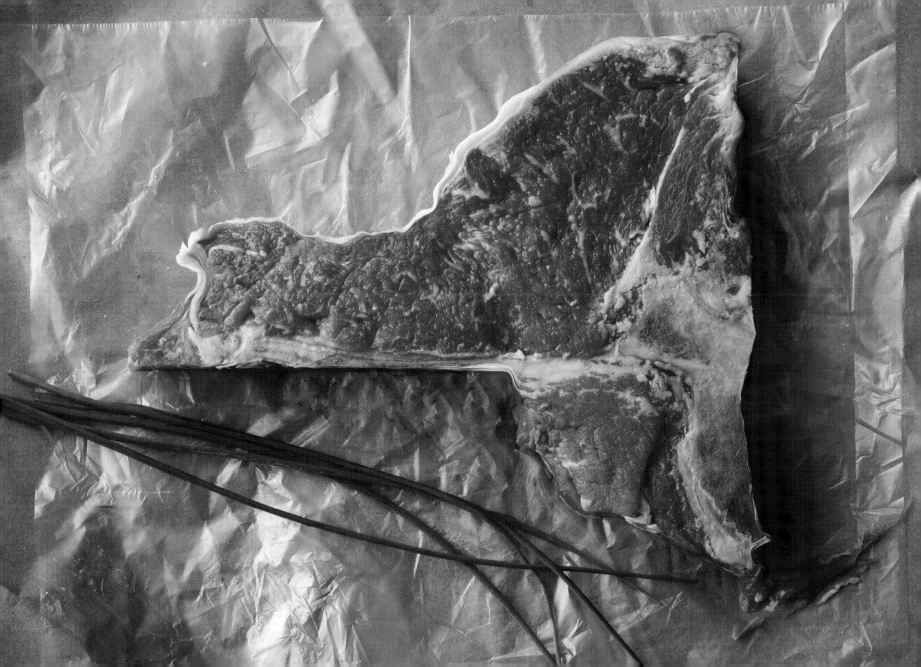

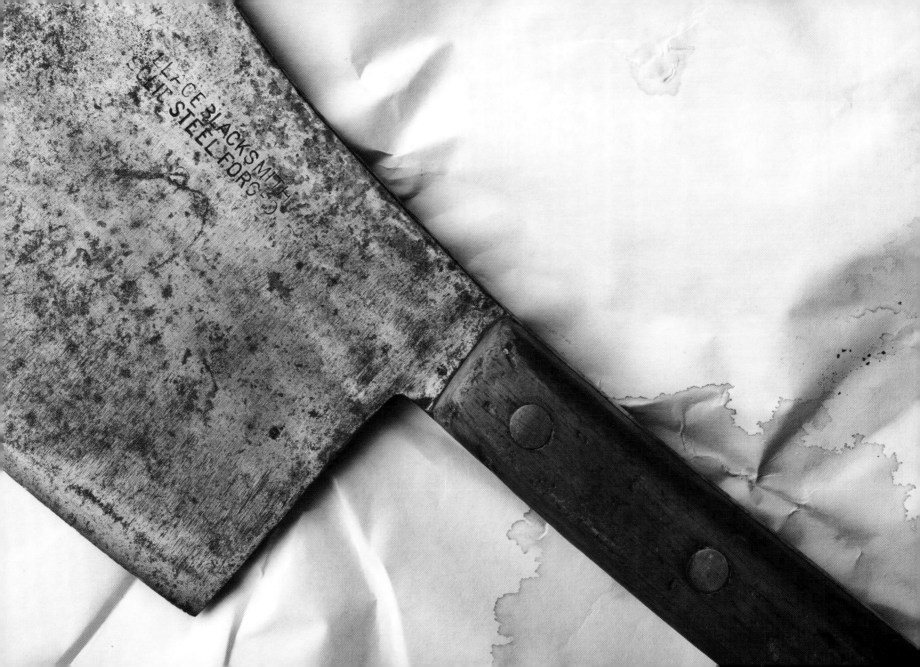

IF GOD DID NOT INTEND FOR US TO EAT ANIMALS, THEN WHY DID HE MAKE THEM OUT OF MEAT?

JOHN CLEESE

SURE I WAVE THE AMERICAN FLAG. DO YOU KNOW A BETTER FLAG TO WAVE? SURE I LOVE MY COUNTRY WITH ALL HER FAULTS. I'M NOT ASHAMED OF THAT, NEVER HAVE BEEN, NEVER WILL BE.

JOHN WAYNE

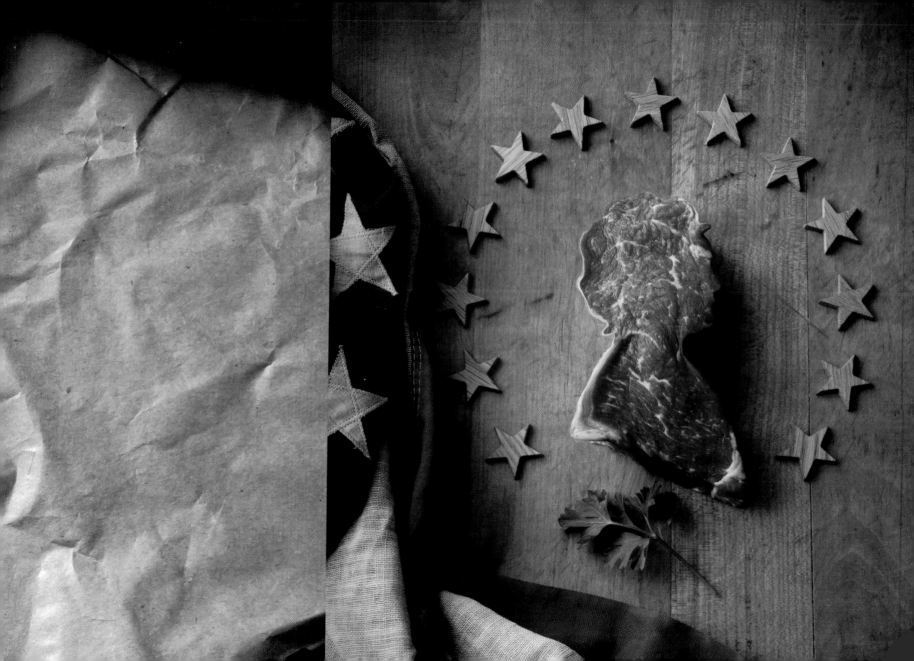

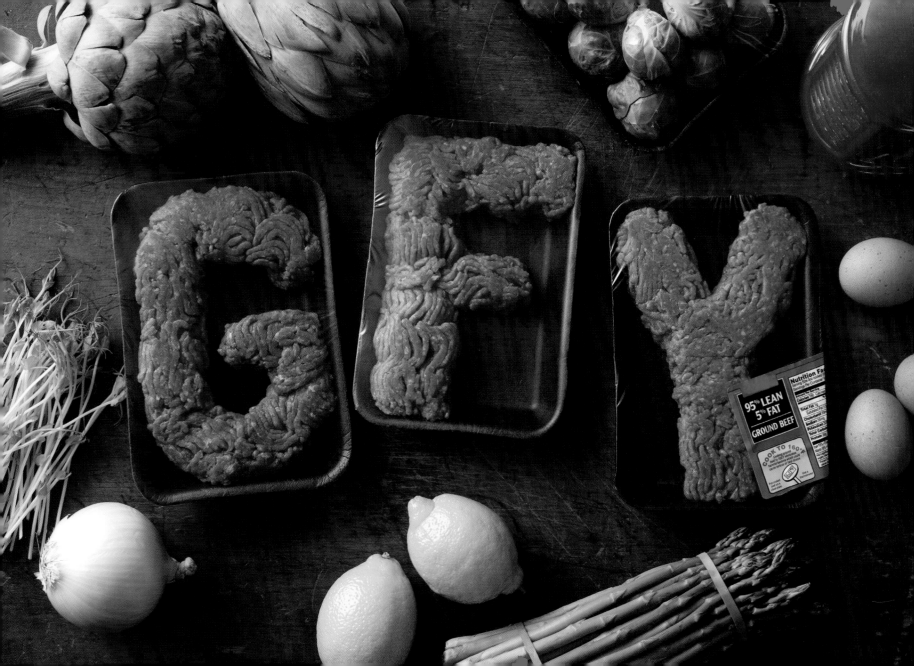

IF I WAS PRESIDENT OF THE GOOD OLD U.S.A., I'D TURN THE CHURCHES INTO STRIP CLUBS AND WATCH THE WHOLE WORLD PRAY.

KID ROCK

I MISS SATURDAY MORNING, ROLLING OUT OF BED, NOT SHAVING, GETTING INTO MY CAR WITH MY GIRLS, DRIVING TO THE SUPERMARKET, SQUEEZING THE FRUIT, GETTING MY CAR WASHED, TAKING WALKS.

BARACK OBAMA

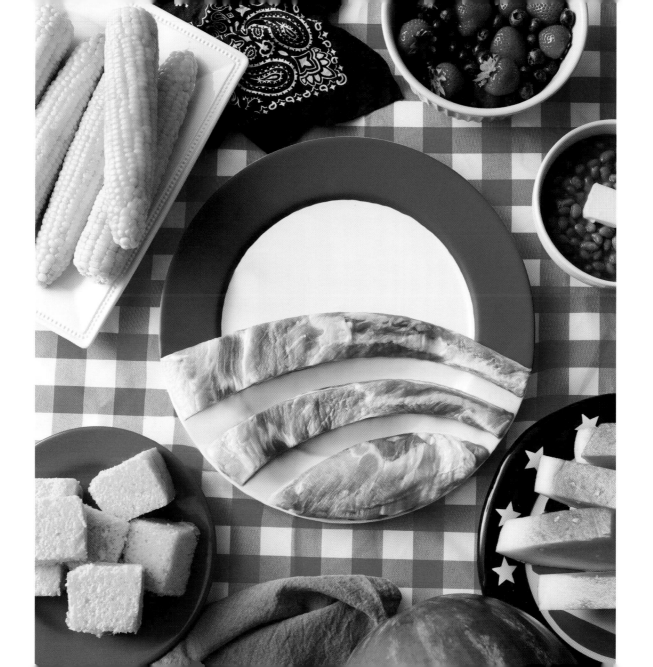

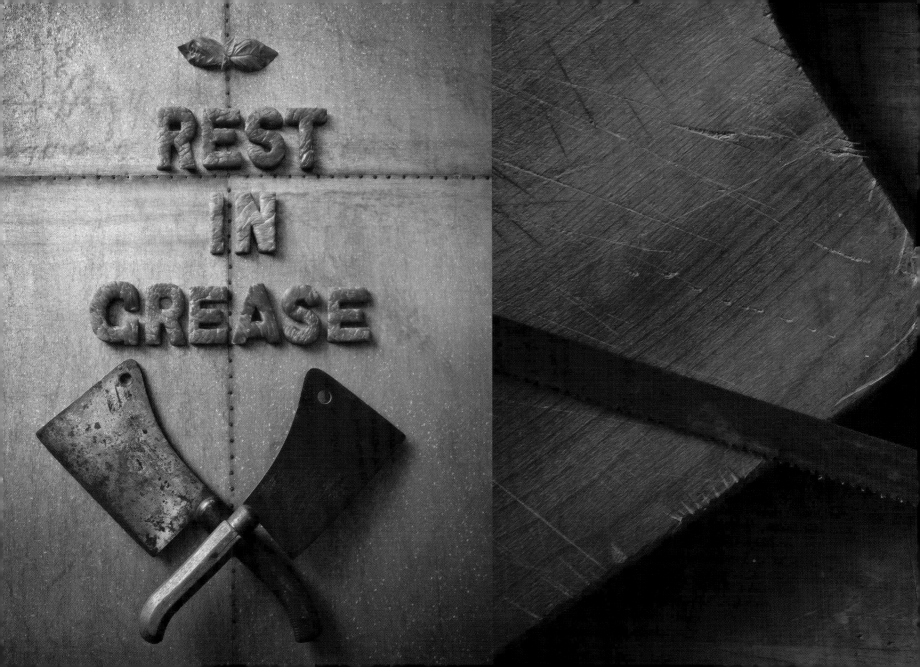

SUICIDE IS MAN'S WAY OF TELLING GOD,
"YOU CAN'T FIRE ME - I QUIT."

BILL MAHER

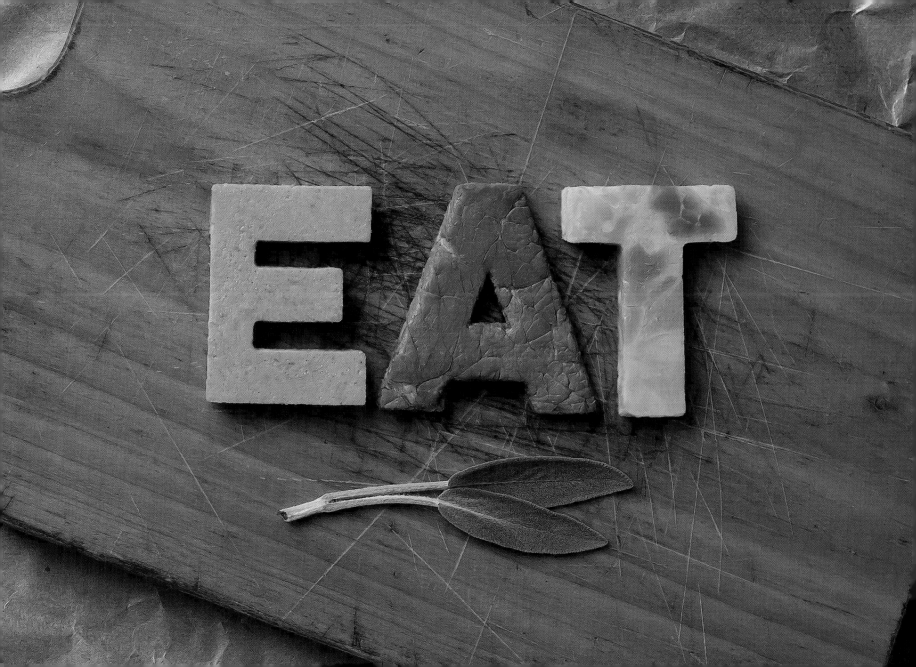

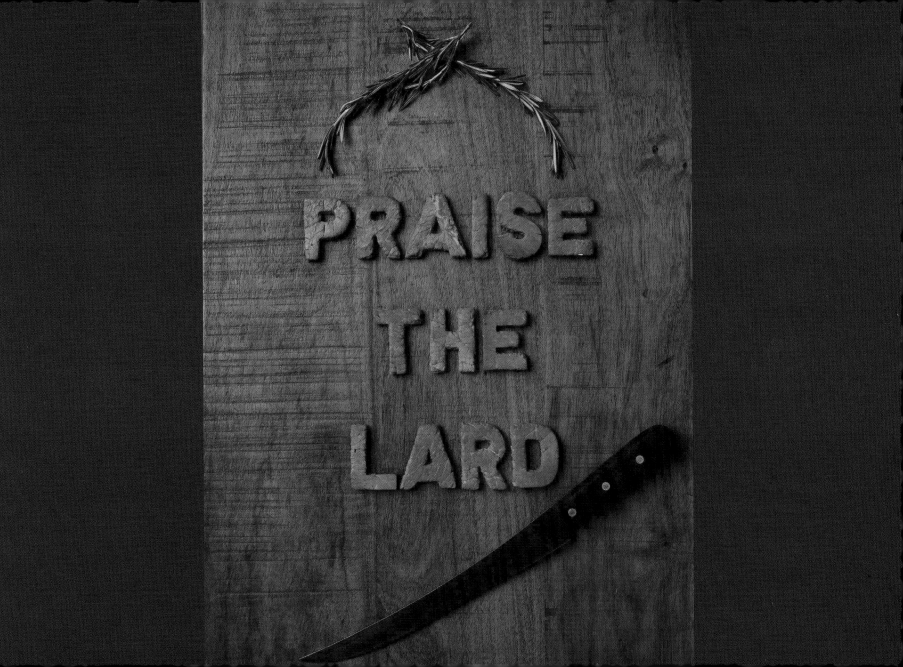

DID YOU EVER SEE THE CUSTOMERS IN HEALTH FOOD STORES? THEY ARE PALE, SKINNY PEOPLE WHO LOOK HALF DEAD. IN A STEAK HOUSE, YOU SEE ROBUST, RUDDY PEOPLE. THEY'RE DYING, OF COURSE, BUT THEY LOOK TERRIFIC.

BILL COSBY

EVERY MORNING I JUMP OUT OF BED AND STEP ON A LANDMINE. THE LANDMINE IS ME. AFTER THE EXPLOSION, I SPEND THE REST OF THE DAY PUTTING THE PIECES TOGETHER.

RAY BRADBURY

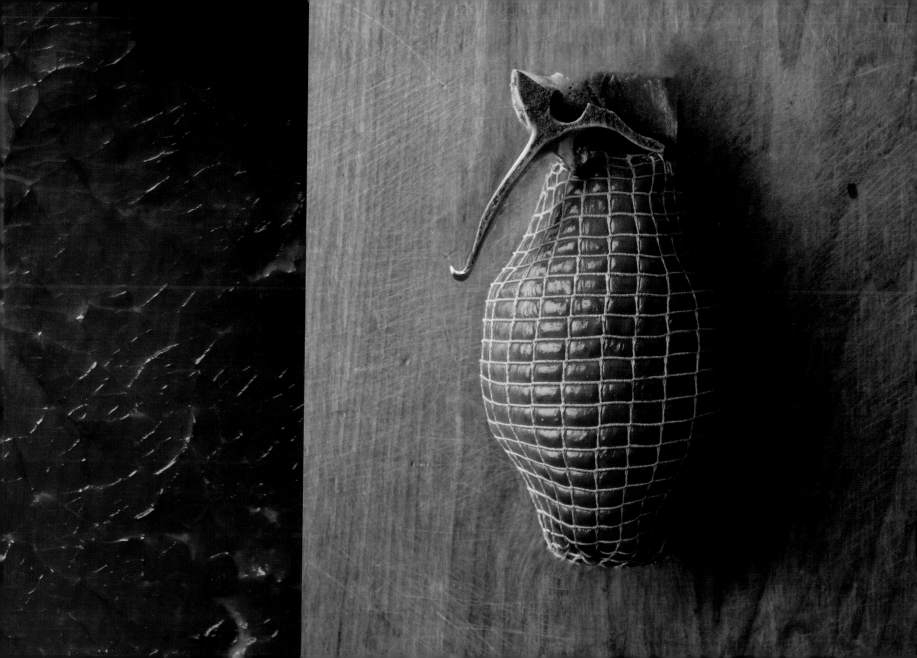

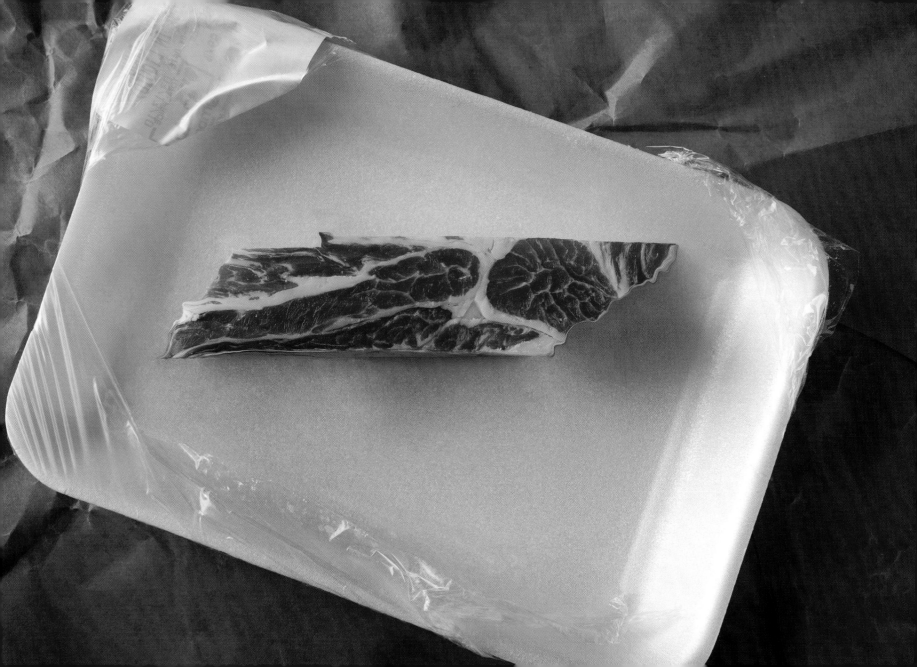

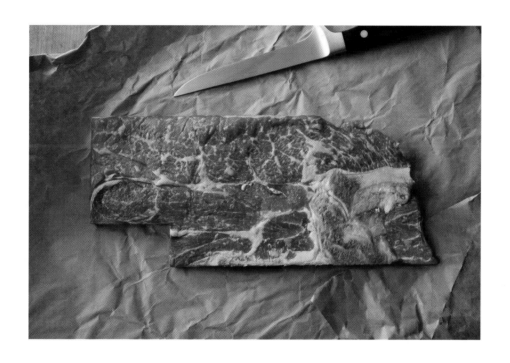

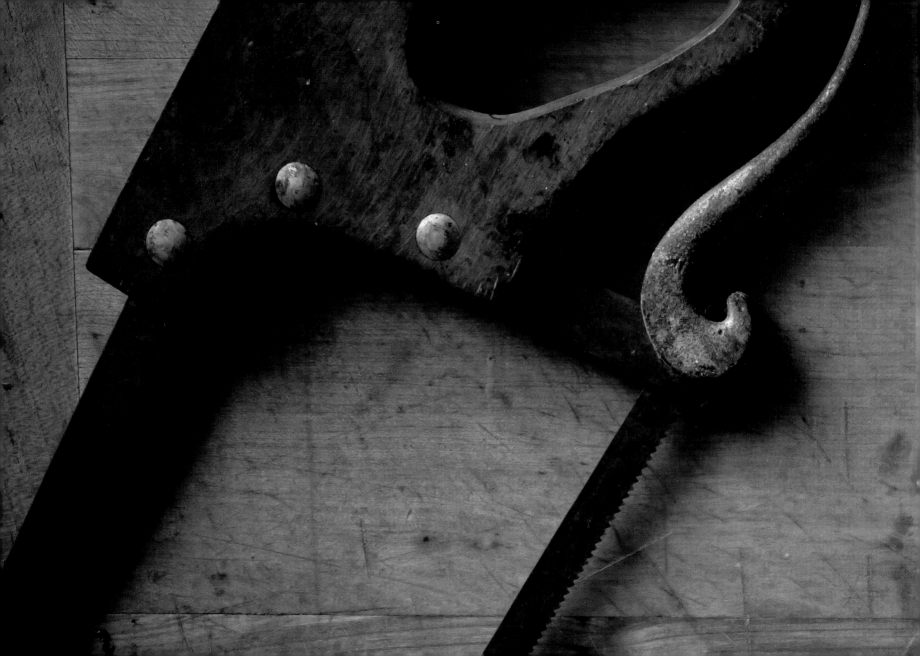

MAN WAS PUT ON THIS EARTH TO EAT MEAT... THE BIBLE SAYS SO DUMBBELL... I MEAN LOOK IT UP WILL YA? ALL THEM OLD BIBLE PEOPLES, THEY WAS ALWAYS EATING MEAT; SOON AS THEY FOUND OUT EATING APPLES WAS WRONG...

ARCHIE BUNKER

LAS VEGAS IS THE ONLY PLACE I KNOW WHERE MONEY REALLY TALKS—IT SAYS, "GOODBYE".

FRANK SINATRA

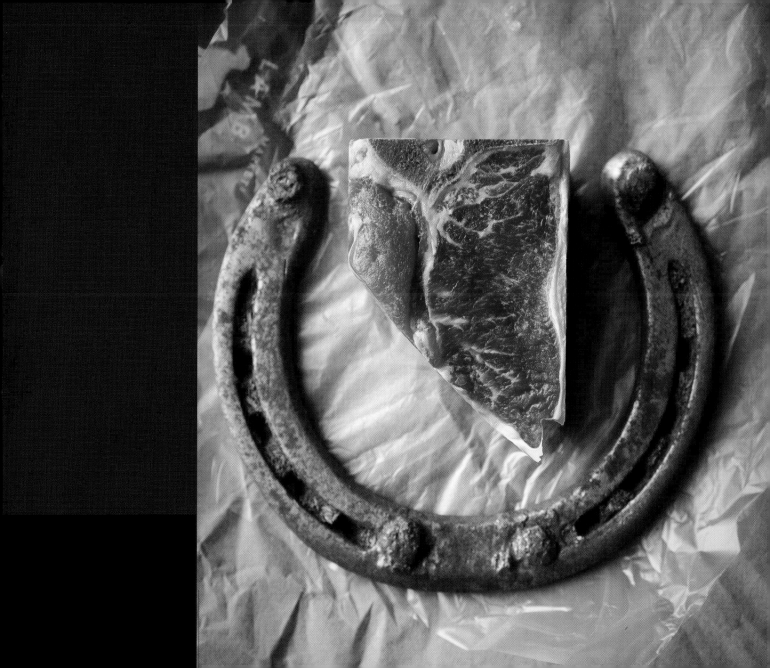

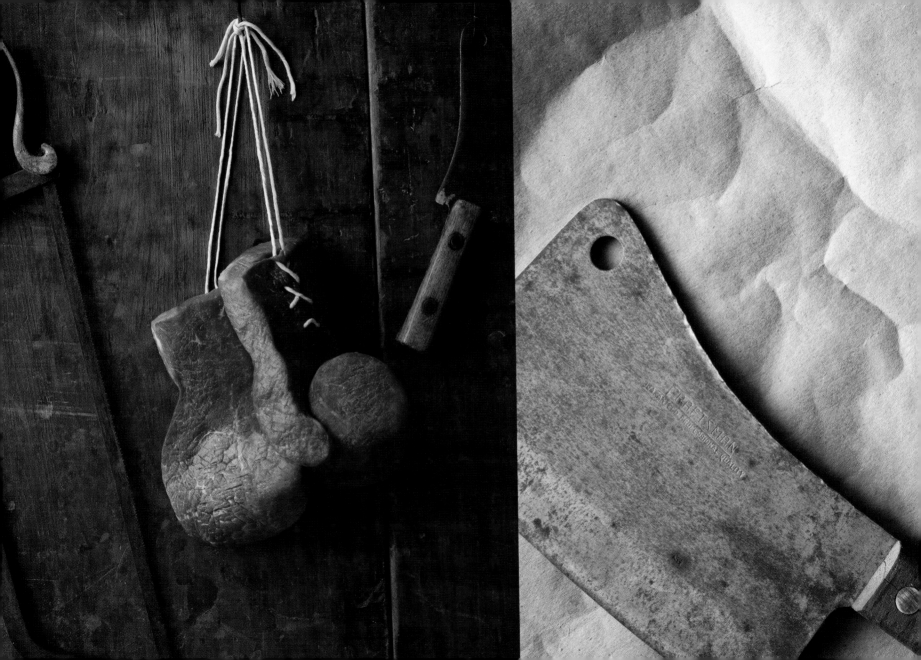

IF YOU EVEN DREAM OF BEATING ME YOU'D BETTER WAKE UP AND APOLOGIZE.

MUHAMMAD ALI

THIS IS A BIG FUCKING DEAL.

JOE BIDEN

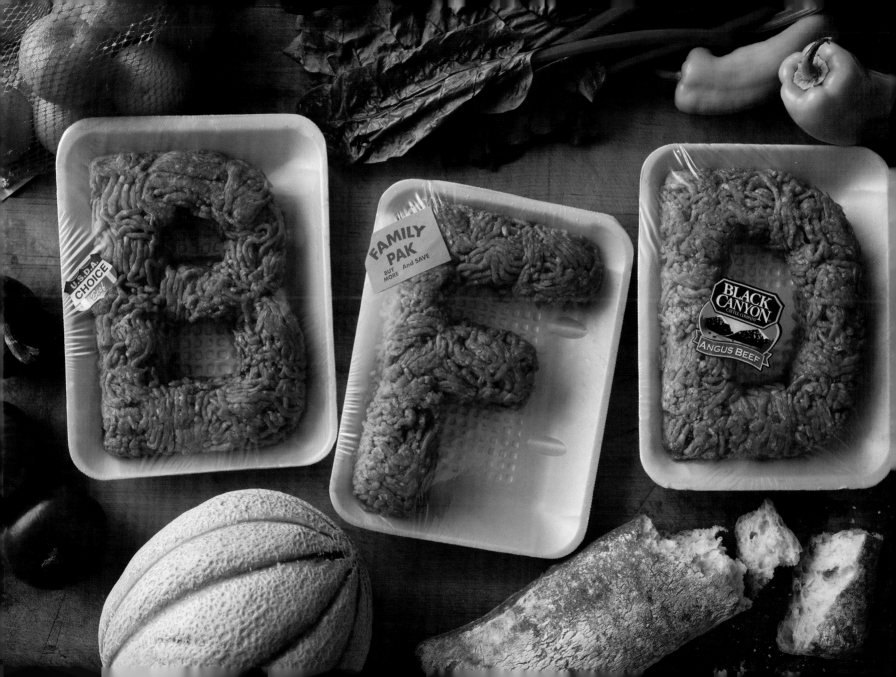

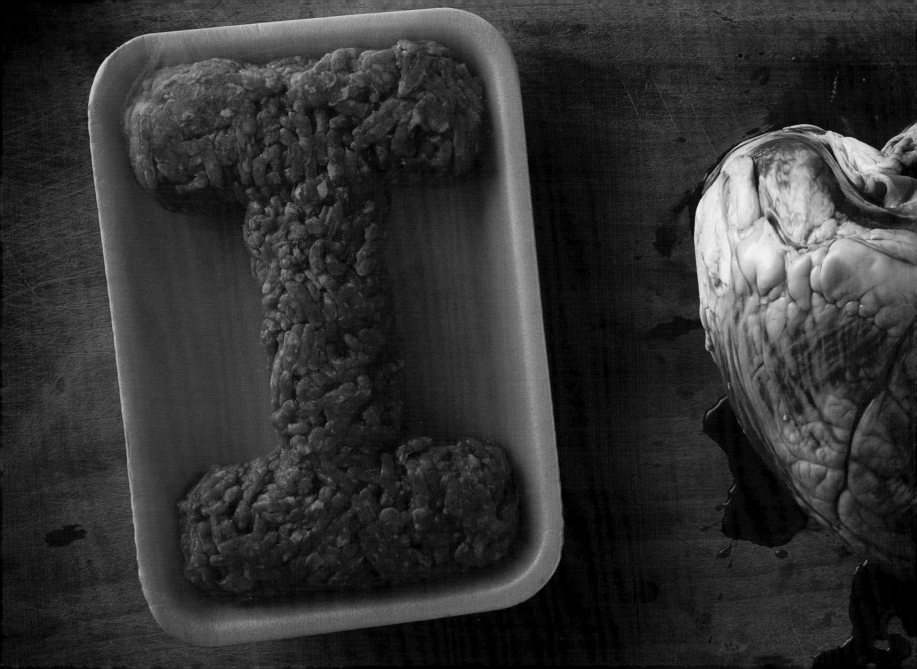

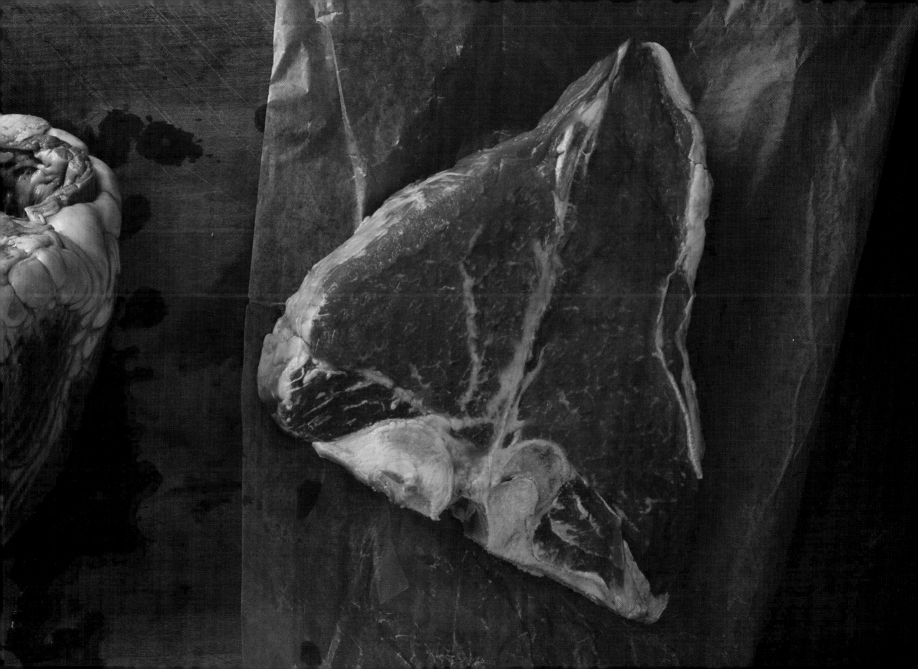

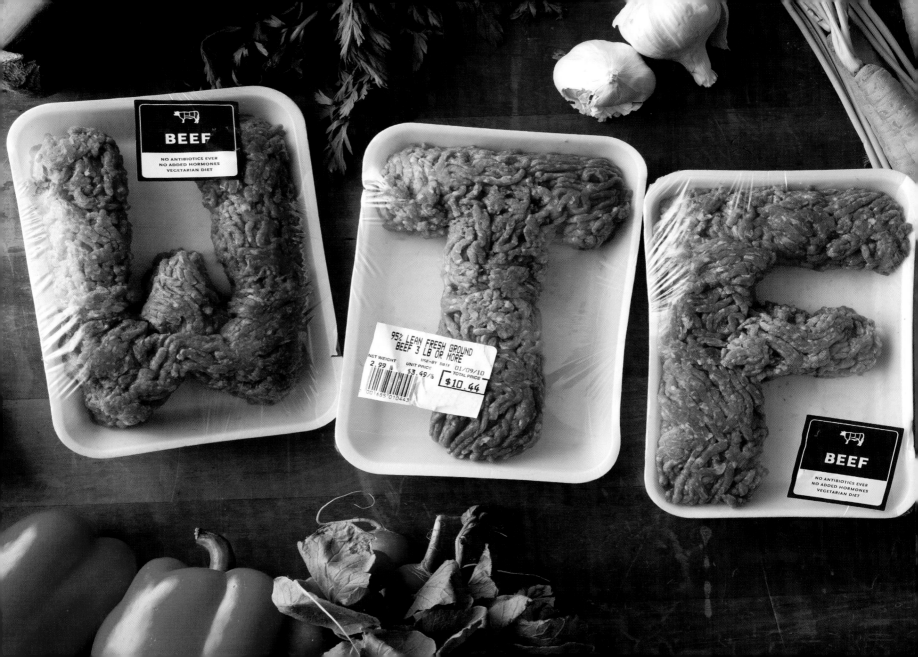

For Michele and Enzo.

I WOULD LIKE TO THANK

David and Jordan for their undying support and belief in me and making this book a
reality. I would like to thank Dawn for her constant love and unconditional support
and my parents for always believing in me. I would also like to thank Candace & Bambi
Gallery, Scott Richards, Andrew Moore, Sagan Medvec, Rick Decoyte & Silicon Gallery,
Finch Brands, The Boys at Trinity, Anastacia Antiques, Joseph & J.,
OSBX, Geri, Brig, Luca Sena, Adam, Machele, Lauren Boggi Goldenberg, Kaitlin.
Ohjoy.com, Todd, Manny and Andrew.

In MEAT AMERICA, artist and photographer Dominic Episcopo focuses on his lifelong passion and most surprising muse: Meat. Serving up inspired and often irreverent translations of the American spirit through a devout carnivore's lens, each of Dom's photographs satisfies our appetite for both art and wit in one bite.

Weegee, the renown American crime photographer, once declared that "many photographers live in a dream world of beautiful backgrounds. It wouldn't hurt them to get a taste of reality to wake them up." With this influence, Dominic confronts the subject of America in an inspired way, raw and uncut.

For some a coffee table book, others a bathroom one, MEAT AMERICA's diverse acceptance is a reflection of America itself. And while reactions range from disgust to praise, there is one common thread that critics and individuals can agree on... that Dominic has tapped into a visceral subject and topic that inspires emotion and ignites thought.

What do you call someone who shoots meat AFTER it has been butchered?
An artist. (but not a starving one)

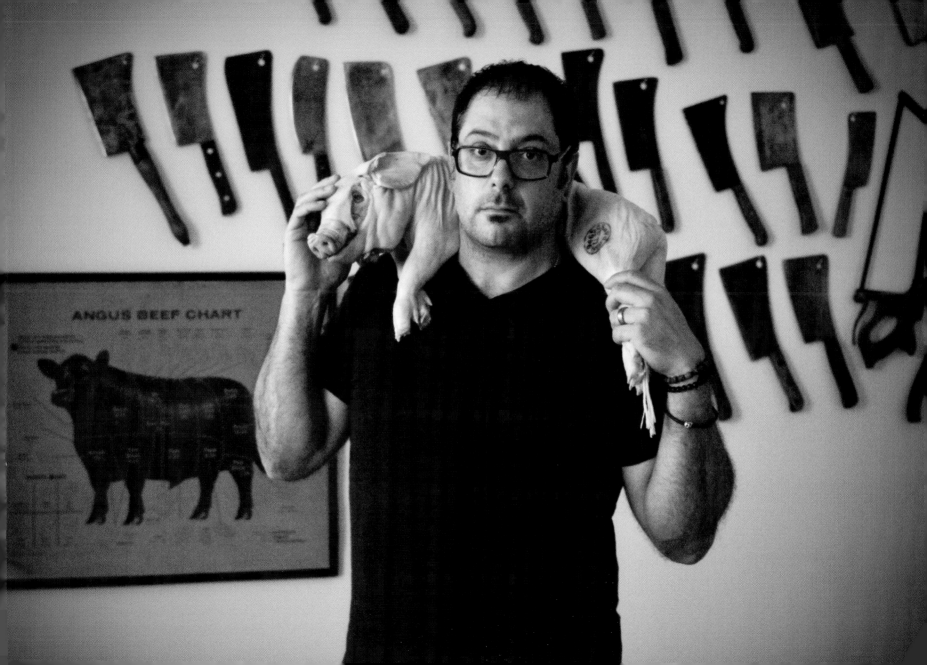

"United Steaks of America" 2007, Rib Eye Steak

"Ben Franklin Rib Eye" 2010, Rib Eye Steak

"Making the Sausage" 2012, Italian Sausage

"I Don't Know" 2010, Cubed Steak

"Lincoln Rib Eye" 2008, Rib Eye Steak

"Love Me Tender" 2010, Filet Mignon

"Dove" 2010, Rib Eye Steak

"Skull & Scallions" 2010, Rib Eye Steak

"Too Much Information" 2010, Ground Beef

"Don't Tread on Meat" 2012, Italian Sausage

"NJ Rib Eye" 2007, Rib Eye Steak

"Hitchcock Rib Eye" 2010, Rib Eye Steak

"Love & Death (Philadelphia Breakfast)" 2009, Ground Beef

"Shank Da Bomb" 2010, Veal Shank

"PA Sirloin" 2007, Sirloin Steak

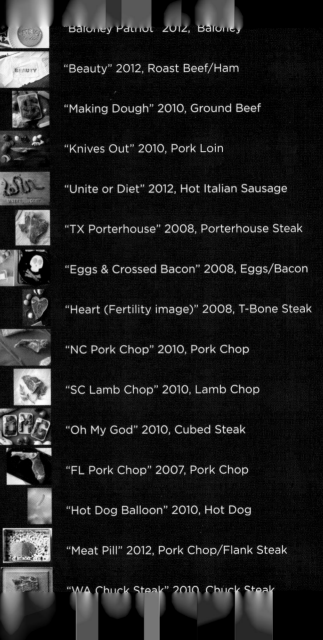

"Baloney Patriot" 2012, Baloney

"Beauty" 2012, Roast Beef/Ham

"Making Dough" 2010, Ground Beef

"Knives Out" 2010, Pork Loin

"Unite or Diet" 2012, Hot Italian Sausage

"TX Porterhouse" 2008, Porterhouse Steak

"Eggs & Crossed Bacon" 2008, Eggs/Bacon

"Heart (Fertility image)" 2008, T-Bone Steak

"NC Pork Chop" 2010, Pork Chop

"SC Lamb Chop" 2010, Lamb Chop

"Oh My God" 2010, Cubed Steak

"FL Pork Chop" 2007, Pork Chop

"Hot Dog Balloon" 2010, Hot Dog

"Meat Pill" 2012, Pork Chop/Flank Steak

"WA Chuck Steak" 2010, Chuck Steak

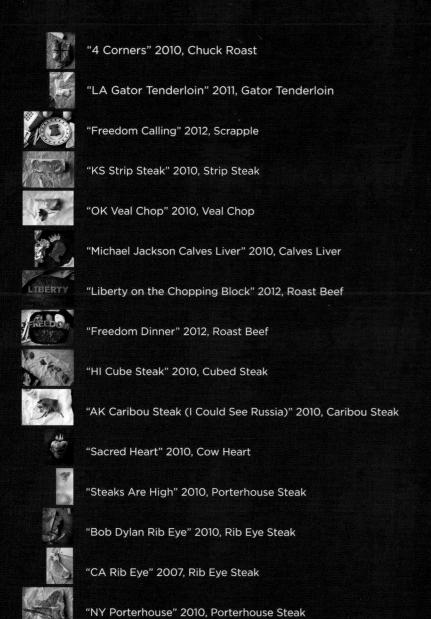

"4 Corners" 2010, Chuck Roast

"LA Gator Tenderloin" 2011, Gator Tenderloin

"Freedom Calling" 2012, Scrapple

"KS Strip Steak" 2010, Strip Steak

"OK Veal Chop" 2010, Veal Chop

"Michael Jackson Calves Liver" 2010, Calves Liver

"Liberty on the Chopping Block" 2012, Roast Beef

"Freedom Dinner" 2012, Roast Beef

"HI Cube Steak" 2010, Cubed Steak

"AK Caribou Steak (I Could See Russia)" 2010, Caribou Steak

"Sacred Heart" 2010, Cow Heart

"Steaks Are High" 2010, Porterhouse Steak

"Bob Dylan Rib Eye" 2010, Rib Eye Steak

"CA Rib Eye" 2007, Rib Eye Steak

"NY Porterhouse" 2010, Porterhouse Steak

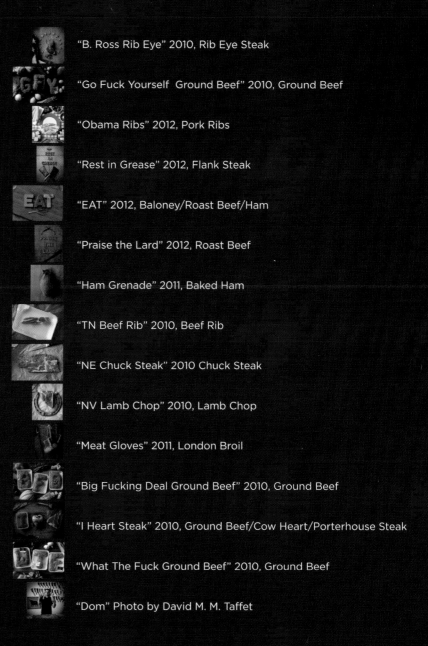

"B. Ross Rib Eye" 2010, Rib Eye Steak

"Go Fuck Yourself Ground Beef" 2010, Ground Beef

"Obama Ribs" 2012, Pork Ribs

"Rest in Grease" 2012, Flank Steak

"EAT" 2012, Baloney/Roast Beef/Ham

"Praise the Lard" 2012, Roast Beef

"Ham Grenade" 2011, Baked Ham

"TN Beef Rib" 2010, Beef Rib

"NE Chuck Steak" 2010 Chuck Steak

"NV Lamb Chop" 2010, Lamb Chop

"Meat Gloves" 2011, London Broil

"Big Fucking Deal Ground Beef" 2010, Ground Beef

"I Heart Steak" 2010, Ground Beef/Cow Heart/Porterhouse Steak

"What The Fuck Ground Beef" 2010, Ground Beef

"Dom" Photo by David M. M. Taffet